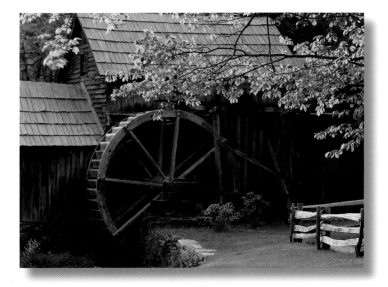

VIRGINIA

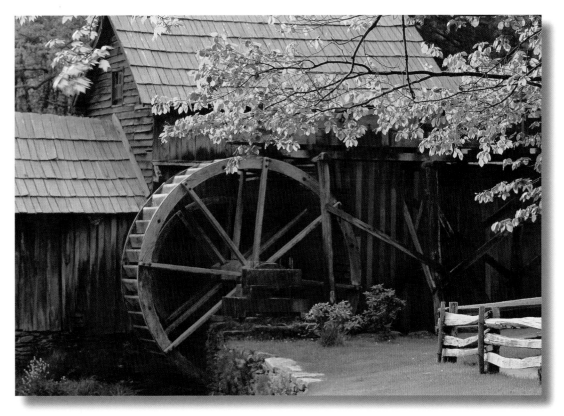

AMERICA SERIES

Text by Tanya Lloyd Kyi
Edited by Elaine Jones
Photo editing by Tanya Lloyd Kyi
Cover and interior layout by Roberta Batchelor

Printed and bound in China

Library of Congress Control Number: 2012945024

ISBN 9781552852569

For more information on the America Series, please visit Midpoint
Trade Books at www.midpointtrade.com.

"Give me liberty or give me death!" These were the words of Virginia lawyer Patrick Henry on the eve of the American Revolution. More than two centuries later, to tour the towns and battlefields of Virginia is to travel through the history of a fledgling United States, to look back to a time when revolutionaries held secret meetings and orators expounded in words so inspiring they still spark the imagination.

There is a romance in these events—a heroism in the commitment of men and women to independence. When George Washington transformed farmers into the Continental Army, and when Thomas Jefferson penned the ideals of the Declaration of Independence, these acts carried the risk of war and the banner of treason against the British Crown. The memory of such devotion is enough to draw more than 3 million annual visitors to Virginia's Yorktown Battlefield at the Colonial National Historic Site, where forces clashed in the final battle of the Revolutionary War in 1781. Another 100,000 sightseers each year tour George Washington's birthplace. Reminders of the American Revolution are every-where in Virginia. The costumed players of Colonial Williamsburg spend each day reliving the lives of ordinary people as the colony moved toward nation-hood. Thomas Jefferson remains alive in the architecture of the State Capitol in Richmond and in Monticello, his sprawling estate.

Of course, the romance of Virginia lies not only in its history, but in the land itself; from the boardwalk stretching along Virginia Beach, with its sun-rise cyclists and its sunset lingerers, to Shenandoah National Park, where trails trace the contours of peaks billions of years old. Even historic battlefields now showcase the beauty of the rolling hills and wetlands. The "Old Dominion," so called for its place in the history of the nation, maintains its rule over the hearts of both residents and visitors.

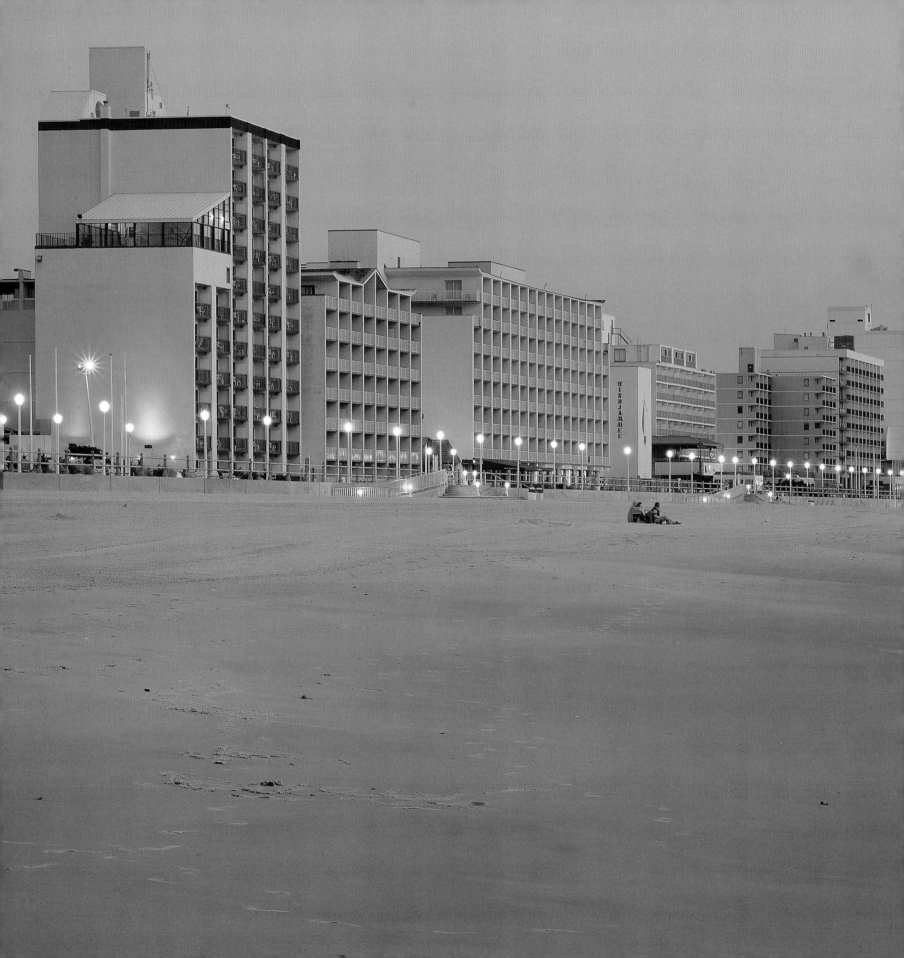

More than 5,000 oceanfront hotel rooms await visitors to Virginia Beach, with another 6,000 just a few blocks away.

7

The first resort was built on Virginia Beach in the 1880s, and sunseekers have been flocking to the shore ever since. Now encompassing more than 300 square miles, the community bills itself as the world's largest resort city.

FACING PAGE –
The first beacon on Cape Henry was built in 1792. After cracks were found in the stone of the old structure, the New Cape Henry Lighthouse was built alongside it in 1881. Fully mechanized, the light continues to guide ships toward Virginia Beach.

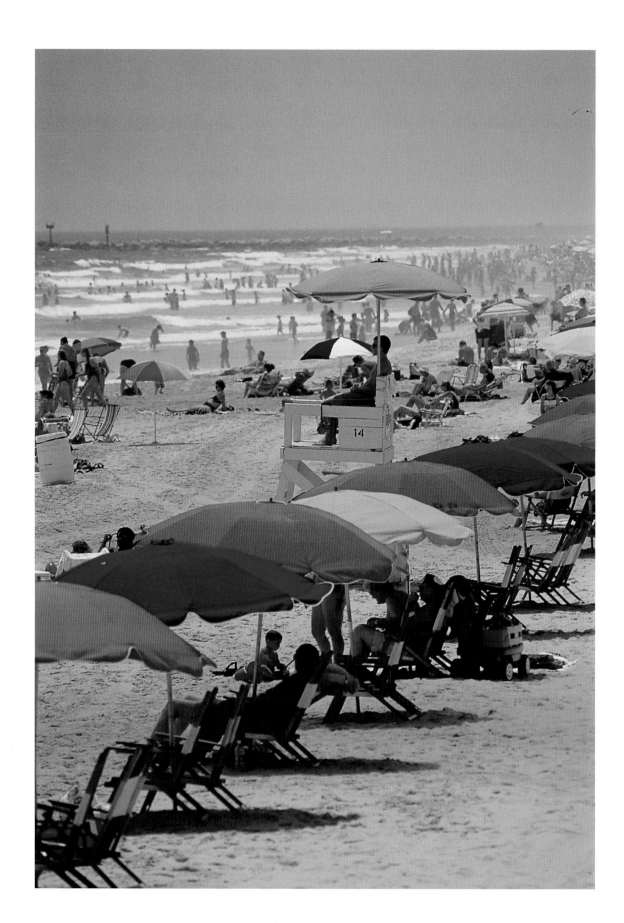

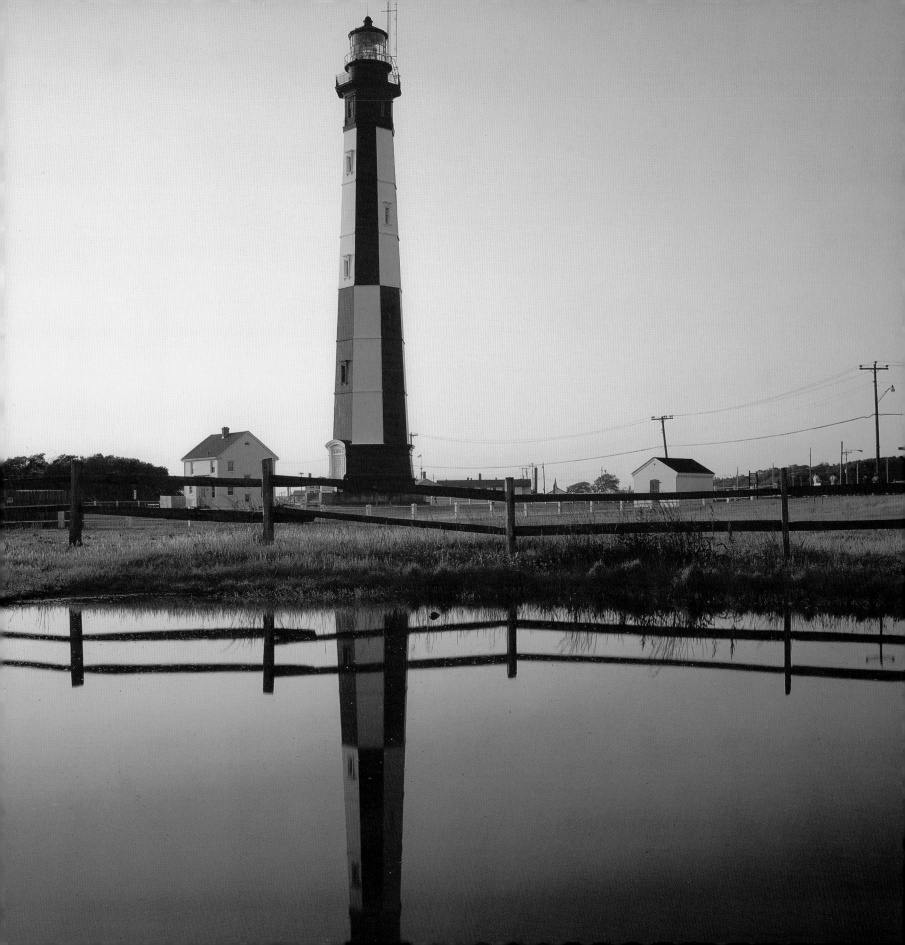

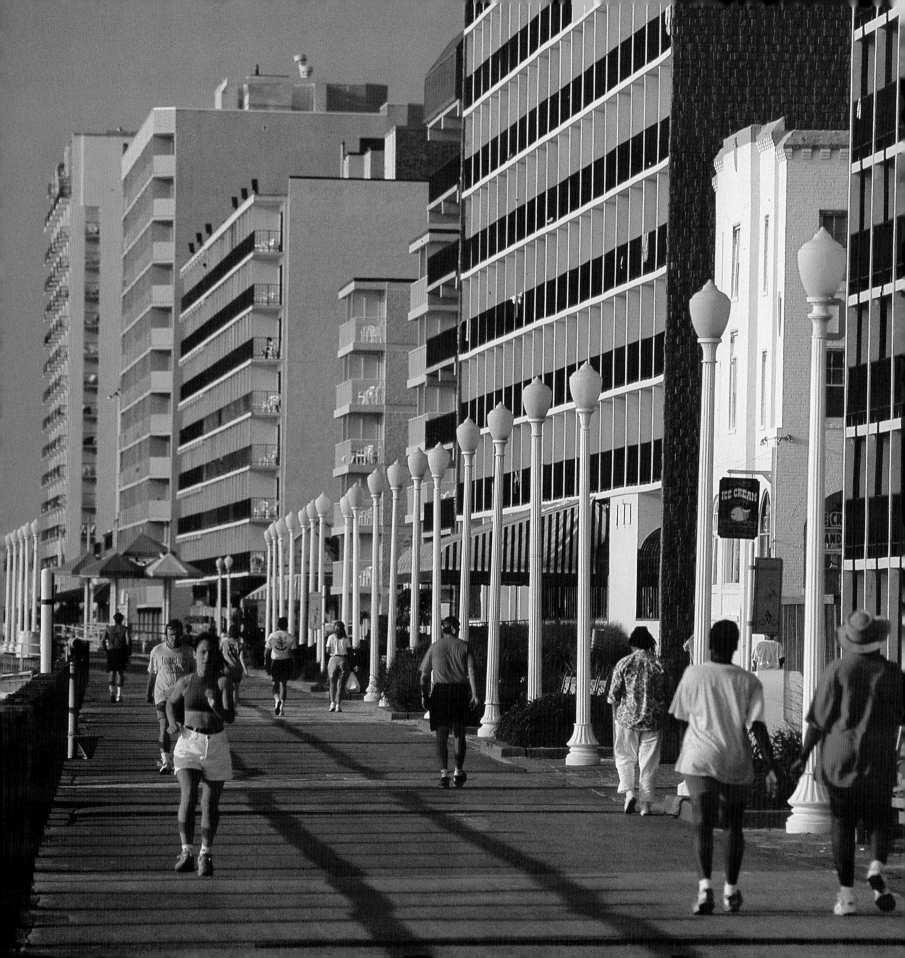

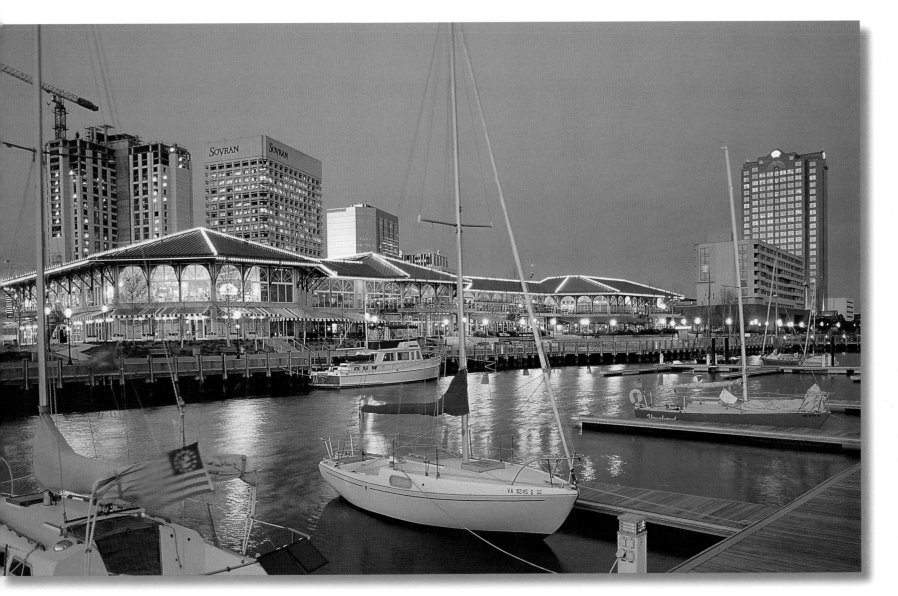

Three ships—the *Susan Constant, the Godspeed,* and the *Discovery*—brought 100 colonists to Virginia Beach in 1607. From here, the new arrivals moved to Jamestown, where they founded the first English settlement in America.

Sightseers can walk for three miles along the picturesque ribbon of boardwalk that traces Virginia Beach from First to Thirty-ninth streets. Quaint wooden benches and ocean-themed sculptures line the boardwalk.

The MacArthur Memorial
in Norfolk commemorates
the life of World War II
hero General Douglas
MacArthur. Visitors can
wander past the general's
grave or explore the muse-
um's extensive collection
of books, correspondence,
and photographs.

FACING PAGE –
Bald cypress and water
tupelo trees grow more
than 150 feet tall in
Seashore State Park near
Virginia Beach. Uniquely
adapted to the wetland's
cycles of flood, the trees
may live for up to 600
years.

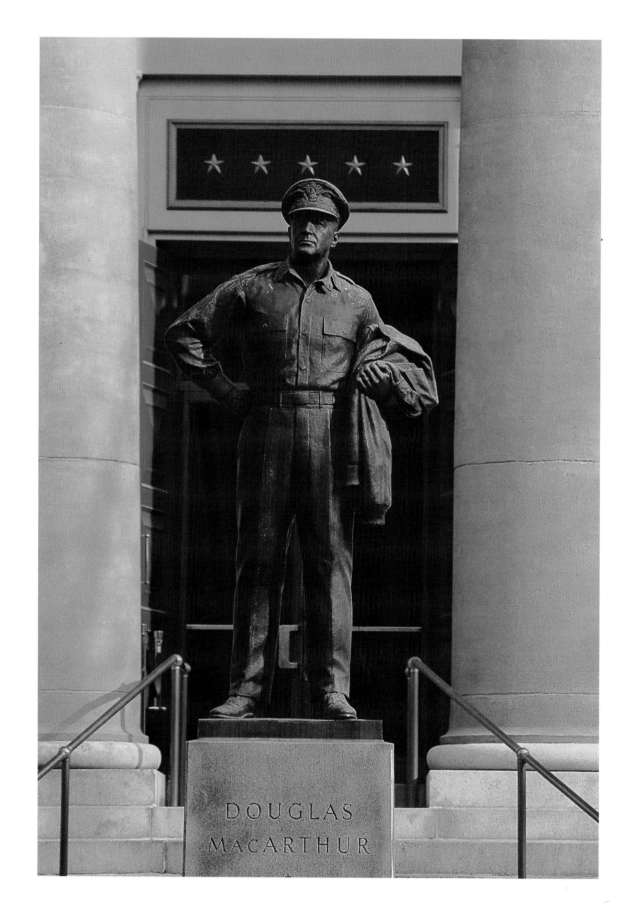

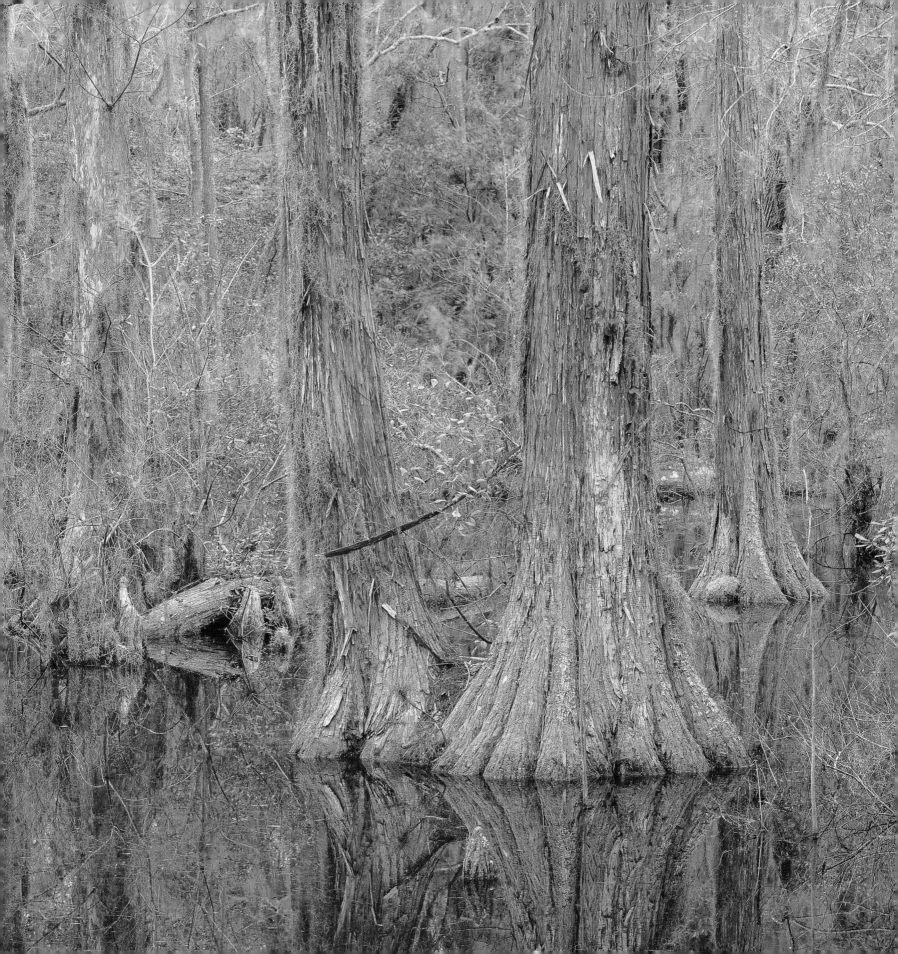

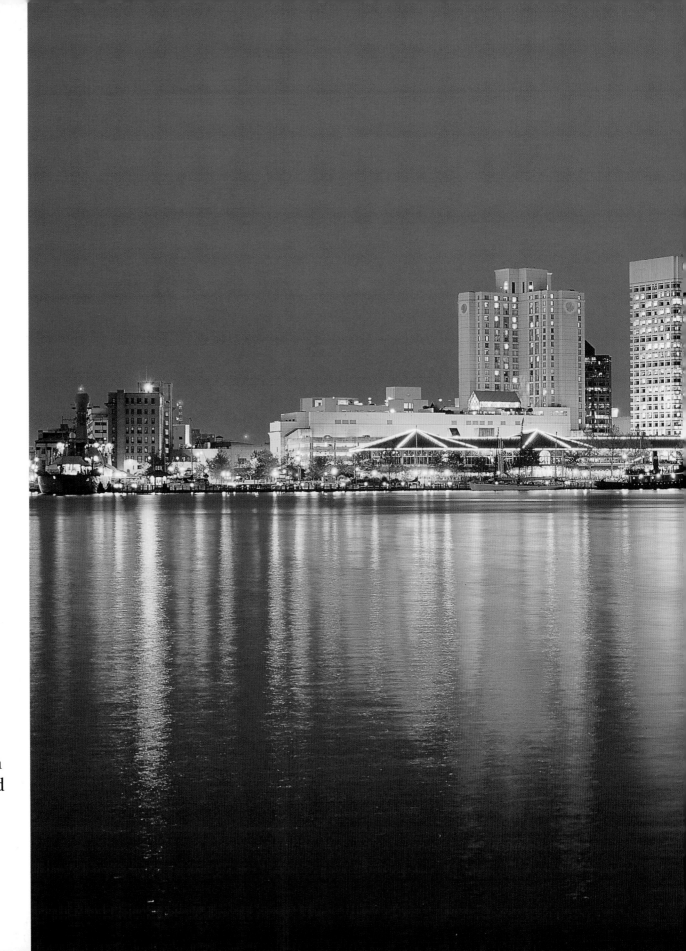

Founded as a seaport more than four centuries ago, Norfolk remains one of the most important harbors on the Atlantic coast. Naval Station Norfolk, established in 1917, is home to 100 ships.

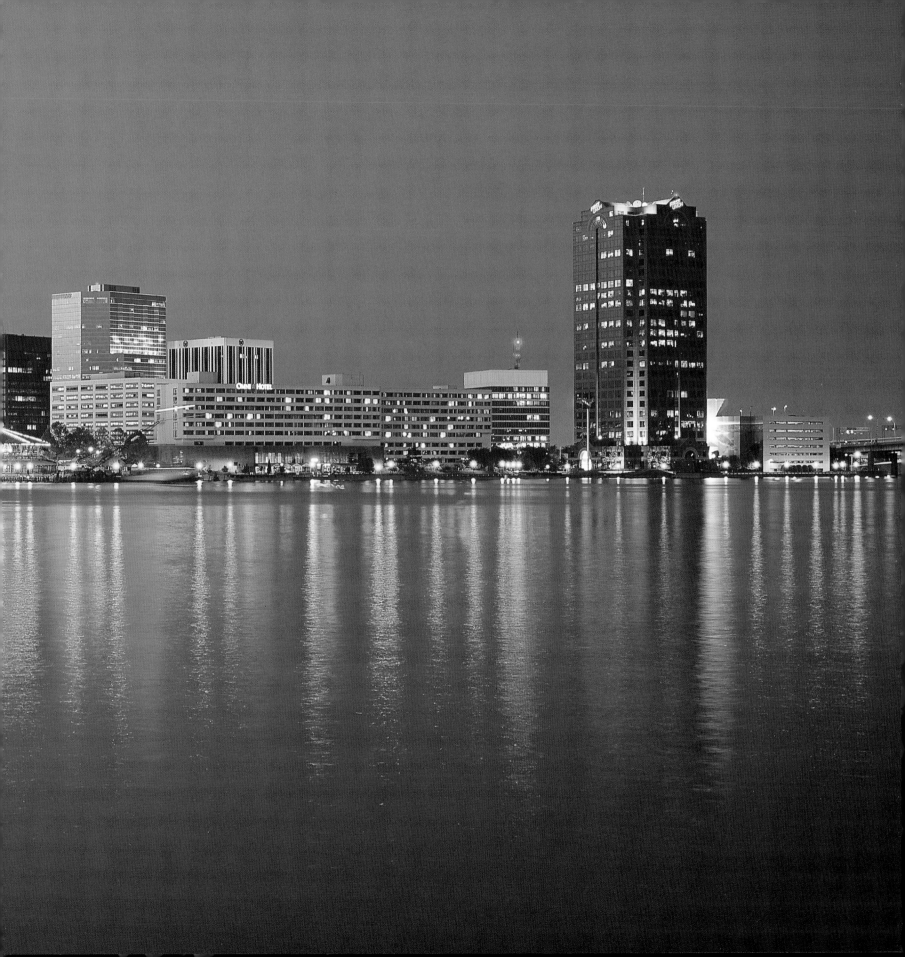

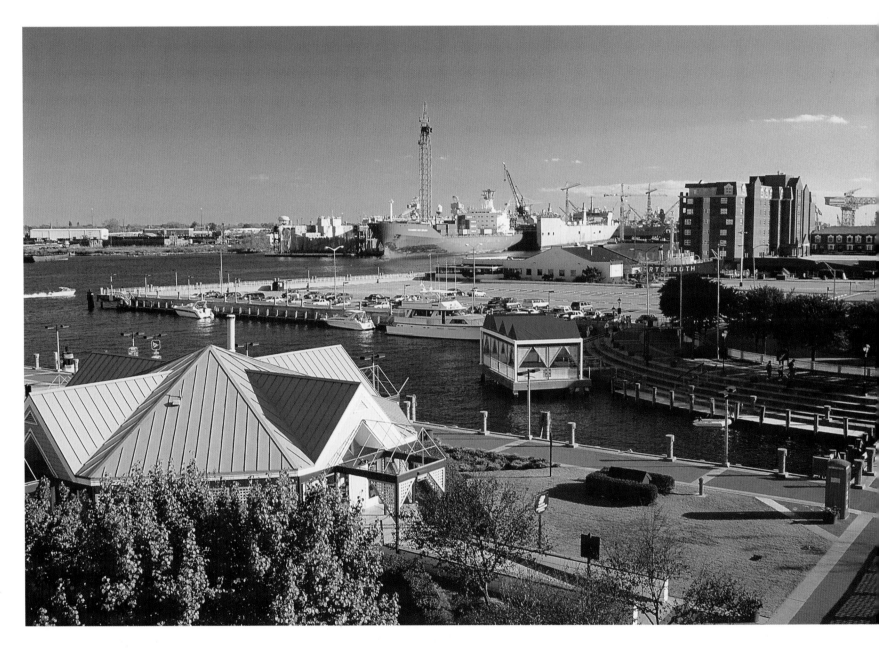

Founded in 1752 by Colonel William Crawford, Portsmouth is
home to America's oldest working shipyard and the oldest U.S.
Navy hospital. Historic homes and shops line the harbor and
the city streets.

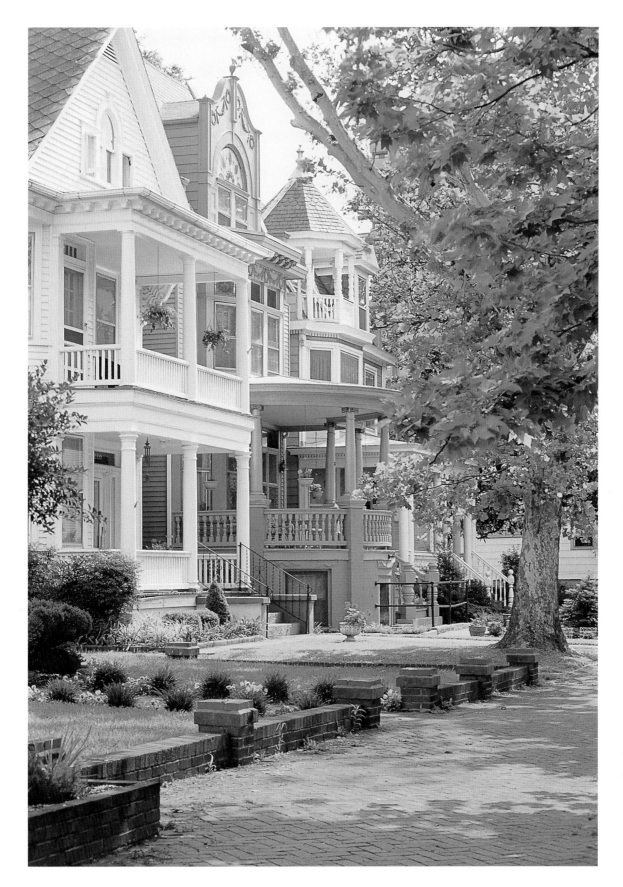

Together, Hampton, Newport News, Norfolk, and Portsmouth comprise one of the nation's busiest commercial ports, Hampton Roads. One of the most accessible natural harbors in the world, it serves 75 international shipping lines.

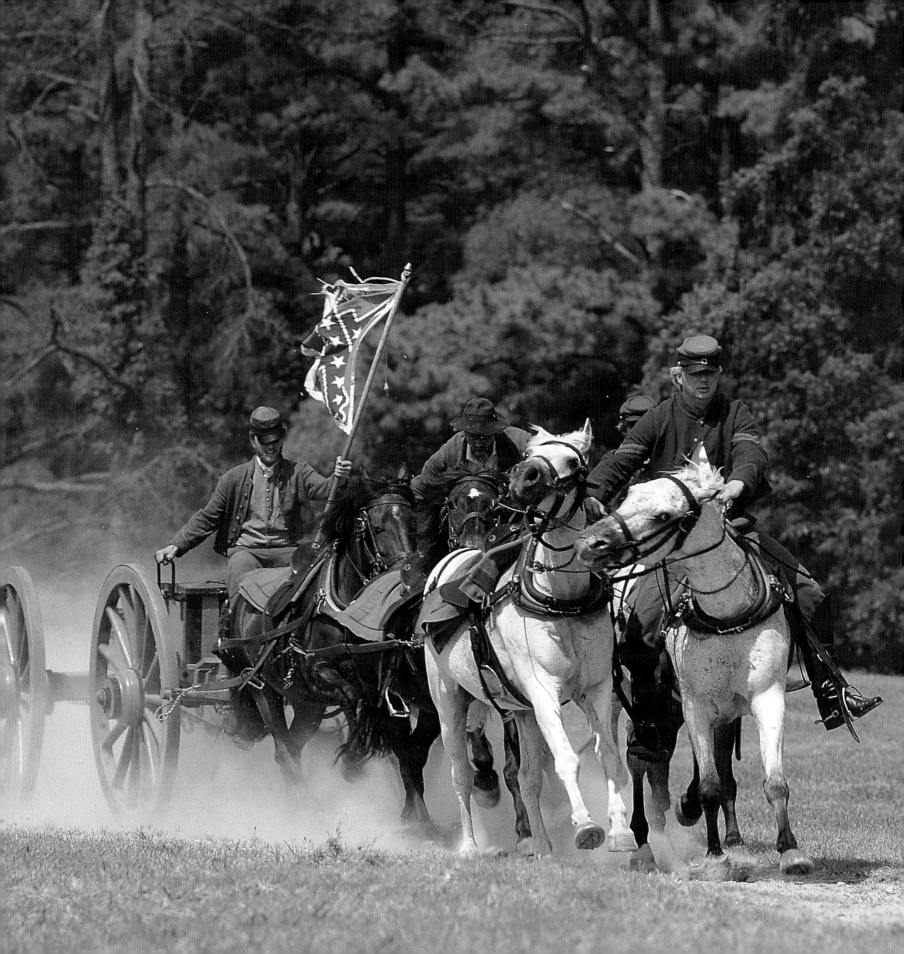

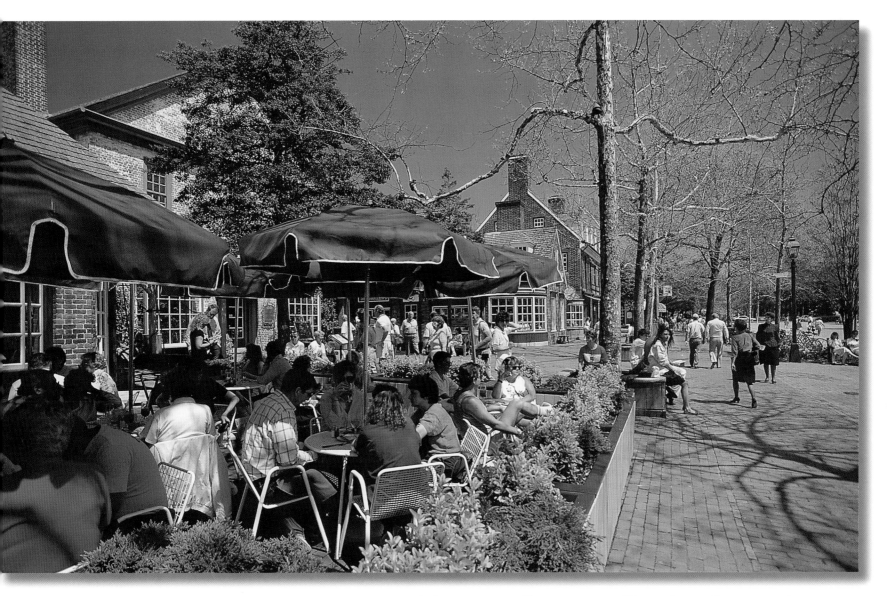

Named for King William III, Williamsburg became the capital of Virginia in 1699. After the capital was moved to Richmond in 1780, Williamsburg remained a college town and county seat.

In 1864, General Ulysses S. Grant laid siege to the city of Petersburg for more than nine months. General Robert E. Lee finally evacuated his troops in April, 1865. Petersburg National Battlefield commemorates the longest siege in American history.

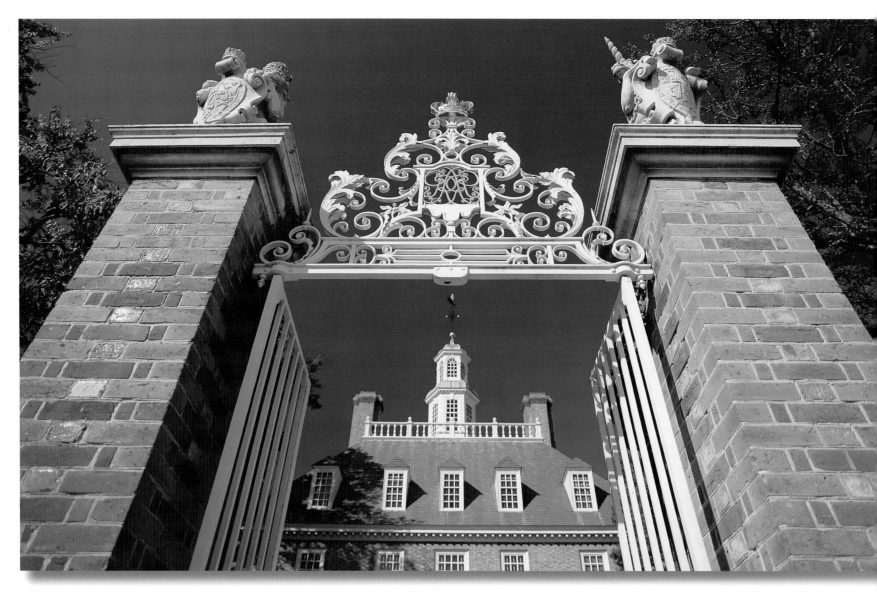

Architects have carefully rebuilt the Governor's Palace in Williamsburg, relying on drawings, sketches, and written descriptions. The original, built in 1722, was once home to Thomas Jefferson.

Dr. W. A. R. Goodwin first dreamed of recreating Colonial Williamsburg in the 1920s. Philanthropist John D. Rockefeller, Jr. provided funding to make the idea become a reality.

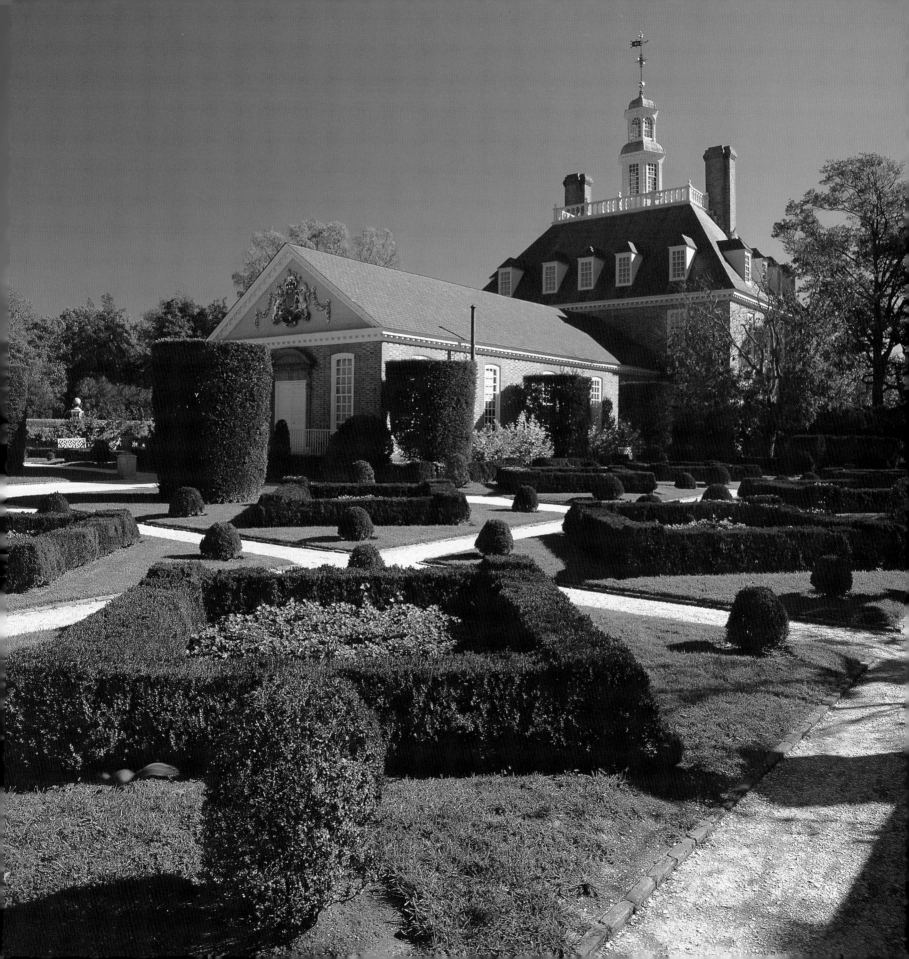

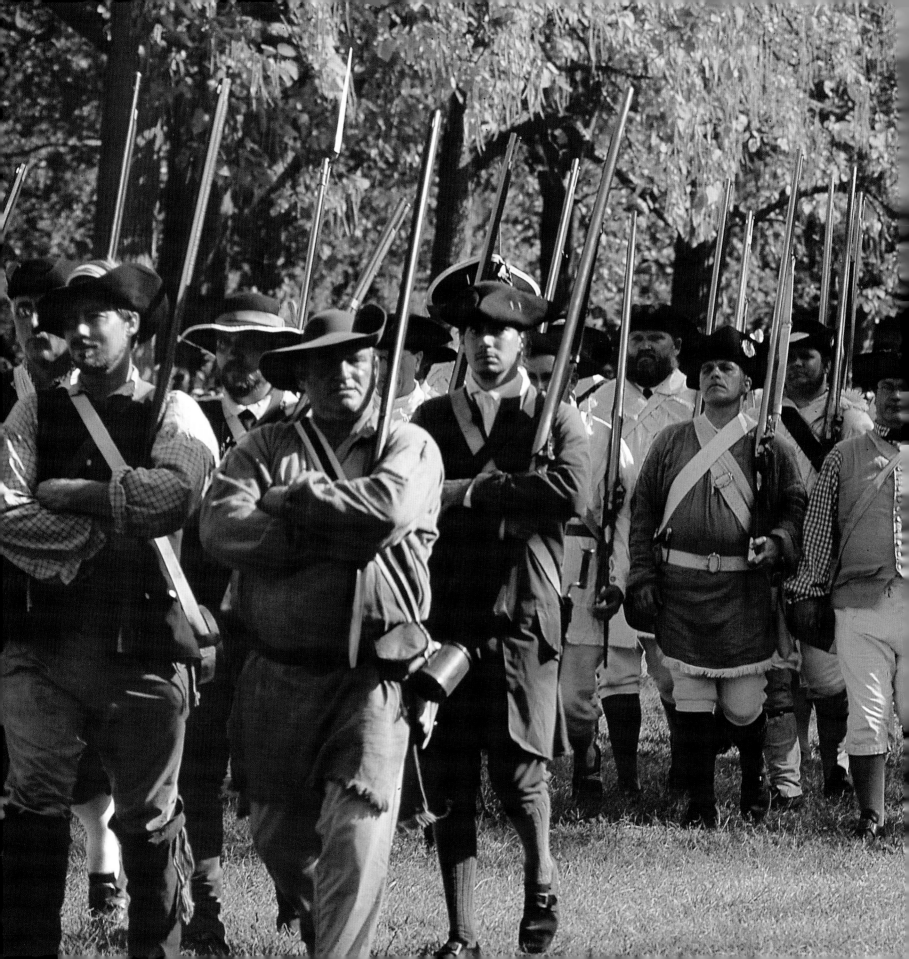

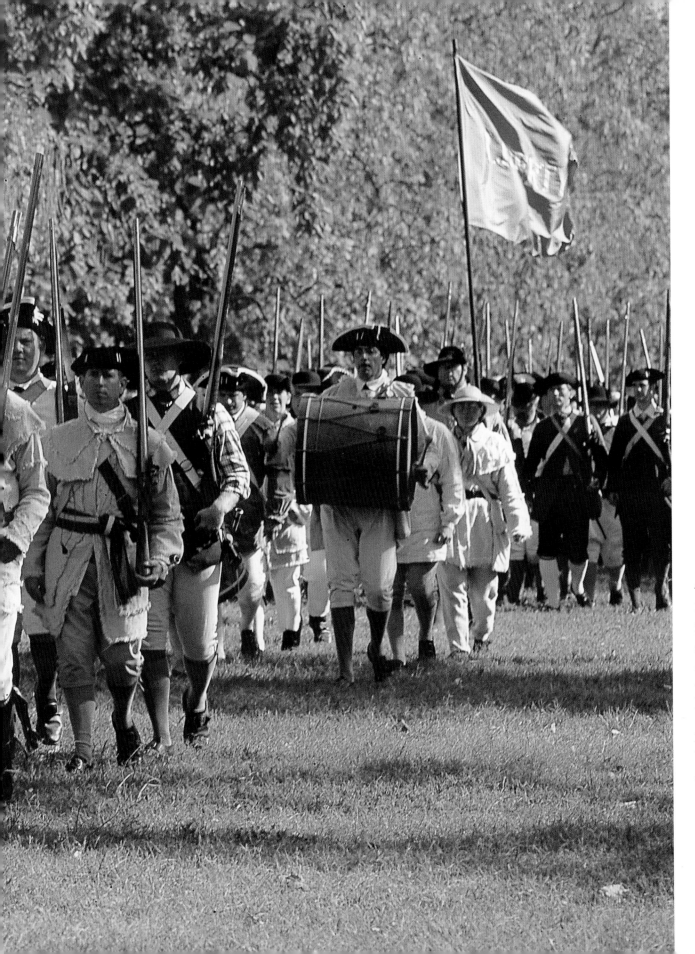

A regiment of the militia parades in front of the Governor's Palace— the center of public life in Colonial Williamsburg. Here, treaties were signed, balls were held, and the best of society strolled in the lush gardens below.

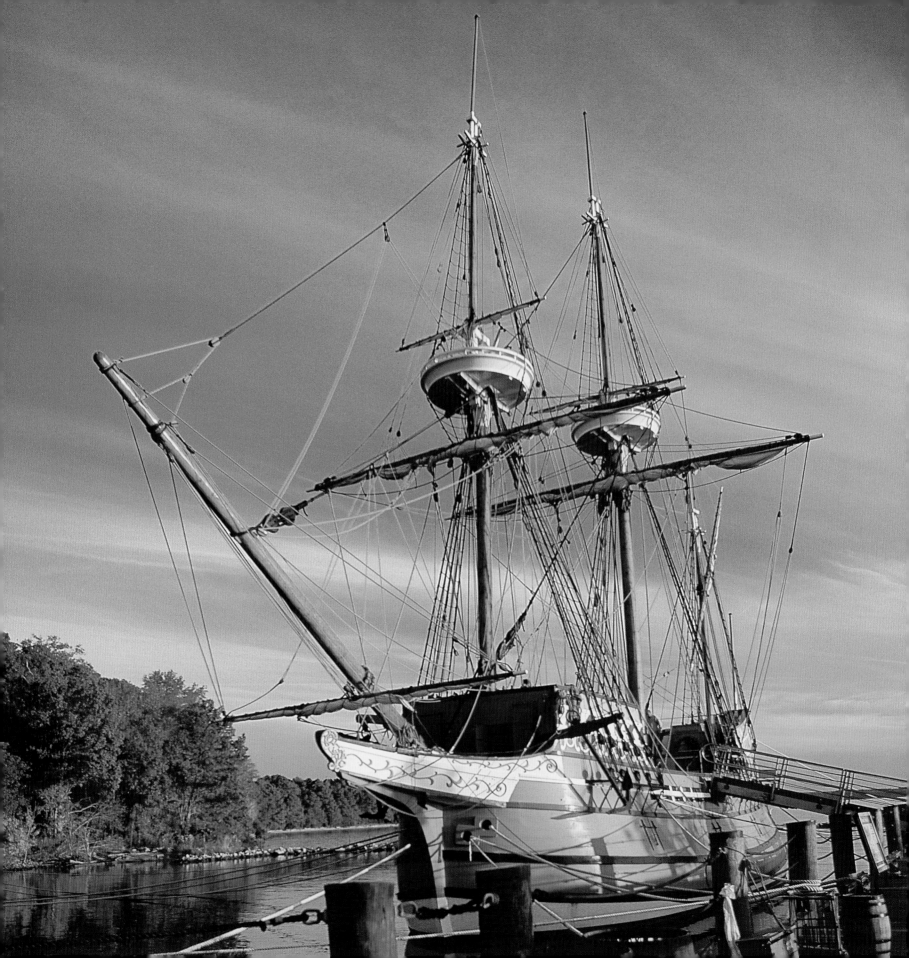

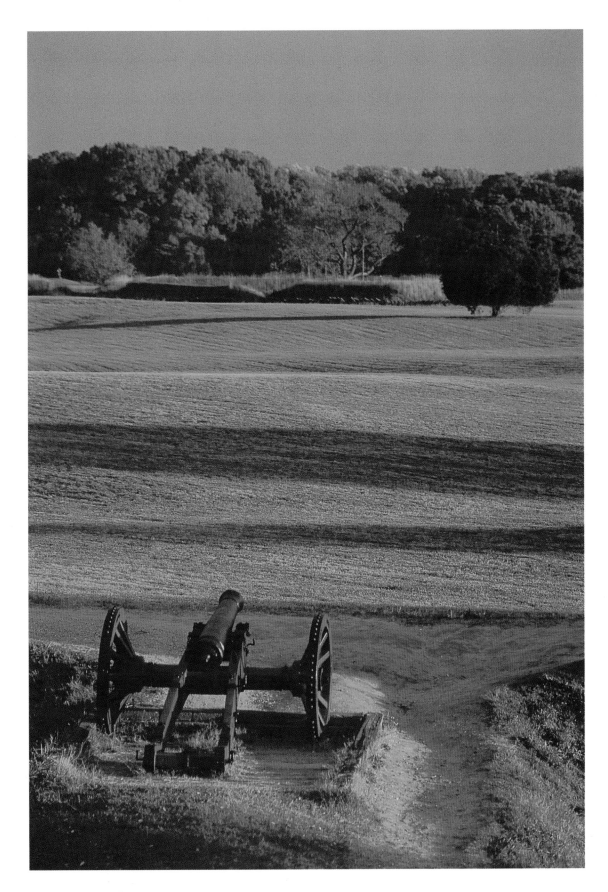

General Charles Lord Cornwallis and the British army were building fortifications in Yorktown in 1781. But when a French fleet blocked their escape through Chesapeake Bay and George Washington's troops descended on their position, Cornwallis's forces were lost and American independence was won.

FACING PAGE –
Visitors aboard the *Susan Constant*, a reconstruction of a ship that America's first English settlers sailed into Jamestown, are swept back in time to 1607. A recreated Powhatan village and a seventeenth-century fort await nearby.

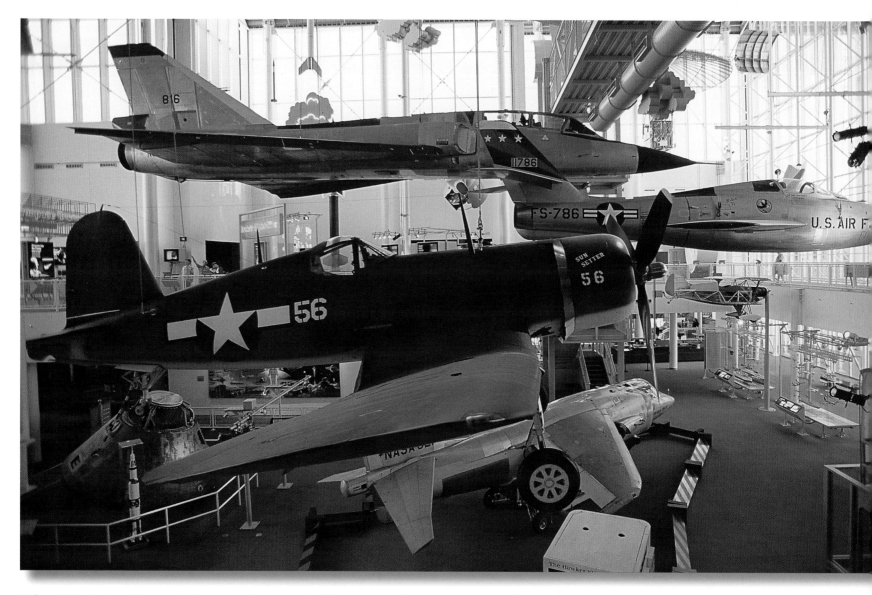

The Virginia Air and Space Center in Hampton boasts more than 100 exhibits, from landing simulators that have helped train American astronauts and a Viking Lander that once visited Mars to fighter jets and helicopters.

Thomas Jefferson designed Virginia's State Capitol in Richmond, basing his creation on the Maison Carrée, a Roman temple in southern France. The State Capitol was completed in 1788; east and west wings were added in 1904.

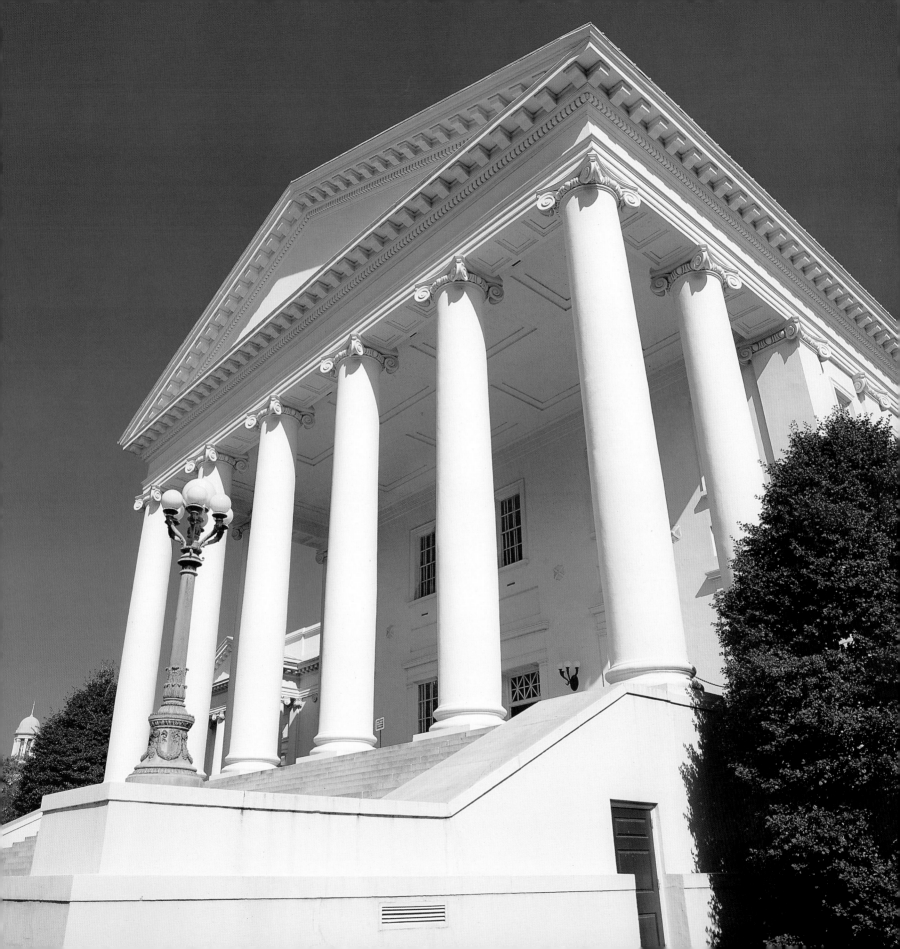

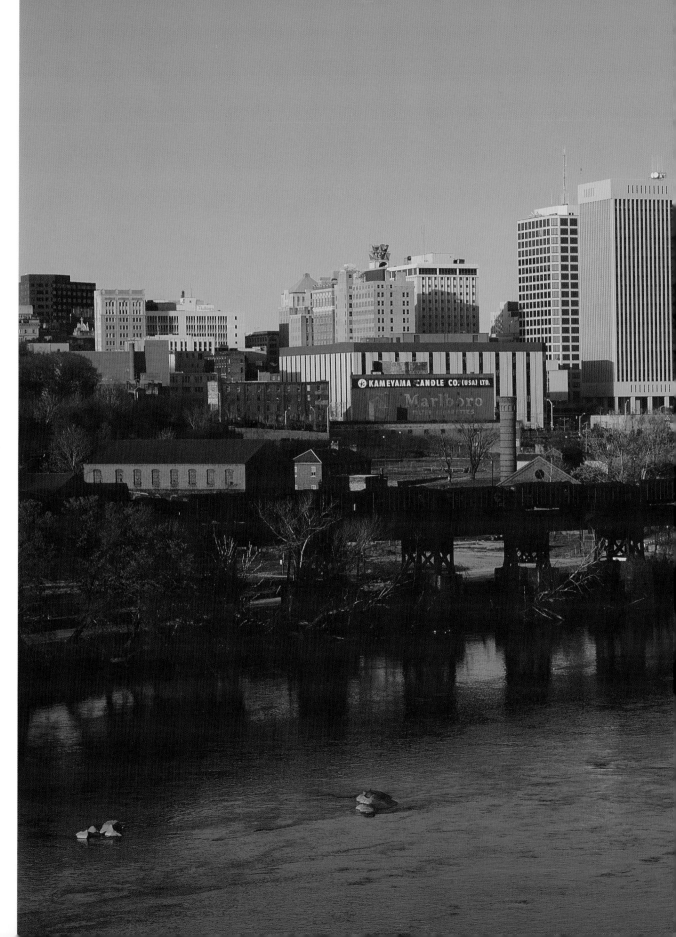

Richmond is not just for history buffs. Rising from the shores of the James River, the city offers a scenic canal walk, serene city parks, and cultural attractions, such as the Virginia Museum of Fine Arts.

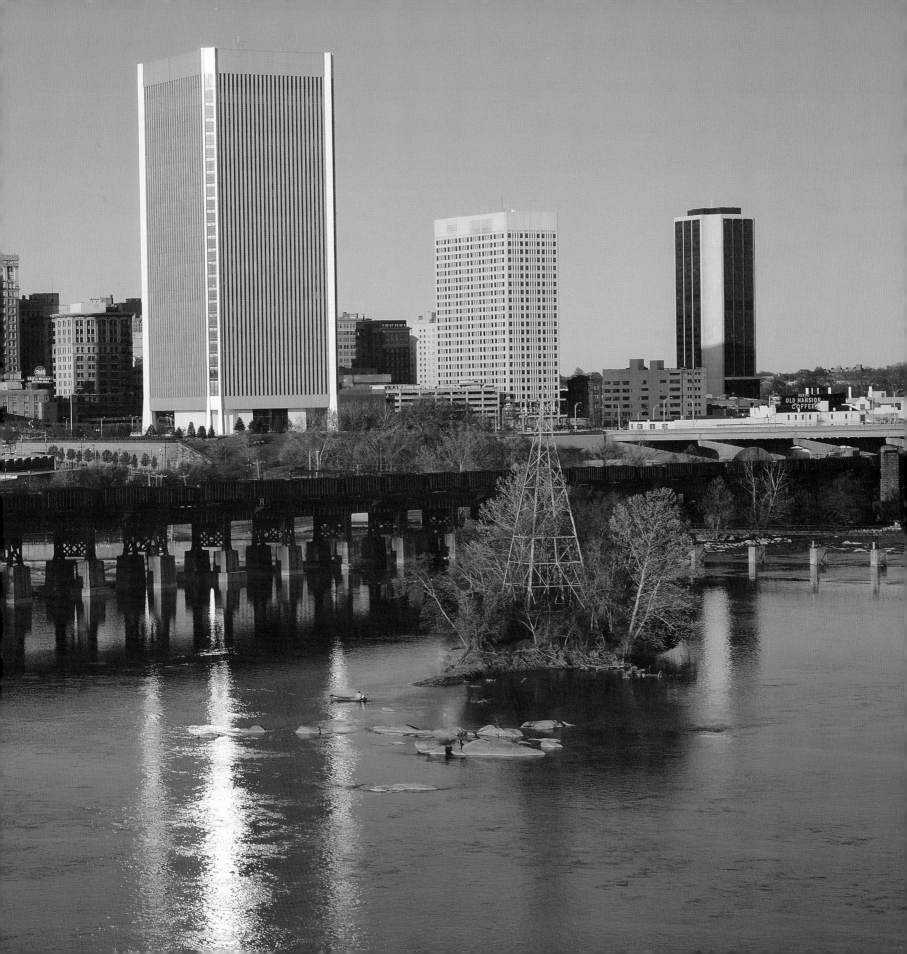

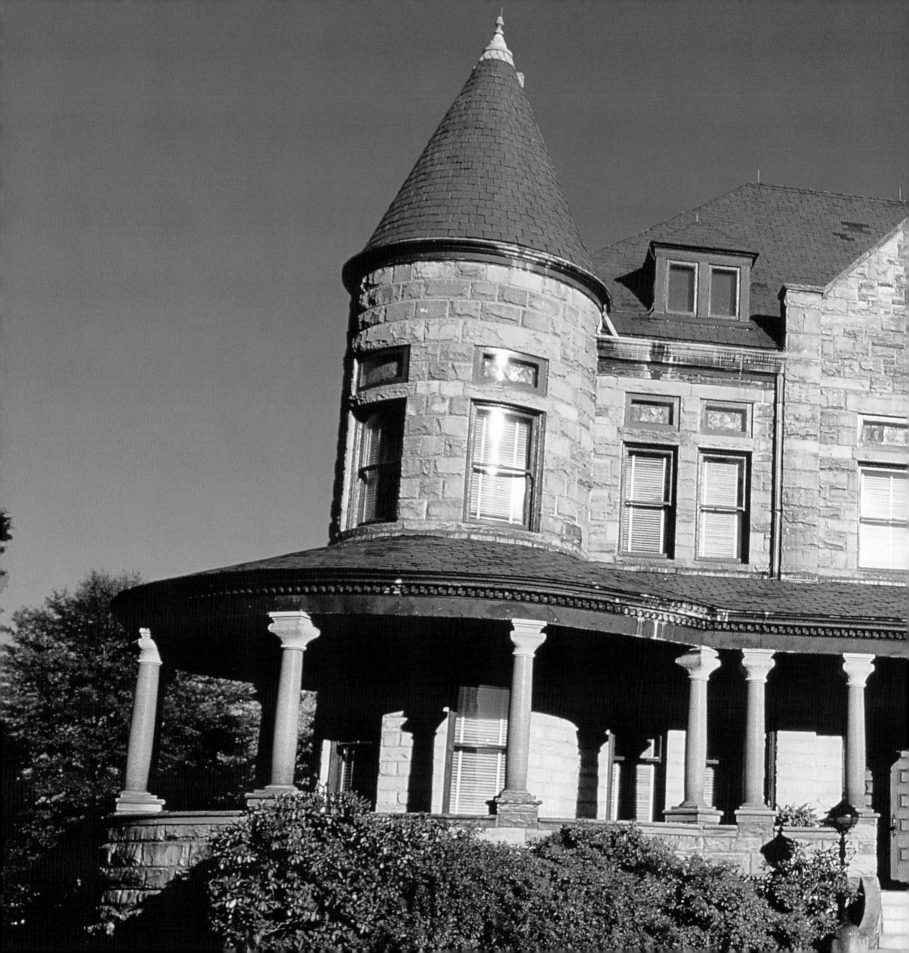

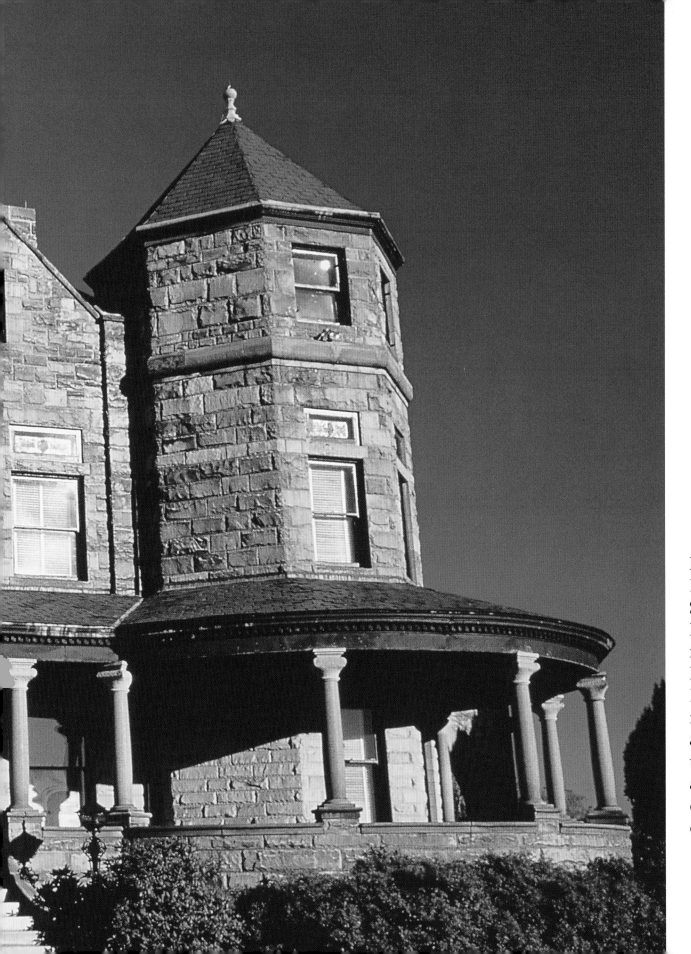

Major James H. Dooley and his wife, Sallie May, lived at Maymont Estate from 1893 until Sallie May's death in 1925. Lush gardens surround the mansion and are now home to a nature center and children's farm, cared for by the city of Richmond.

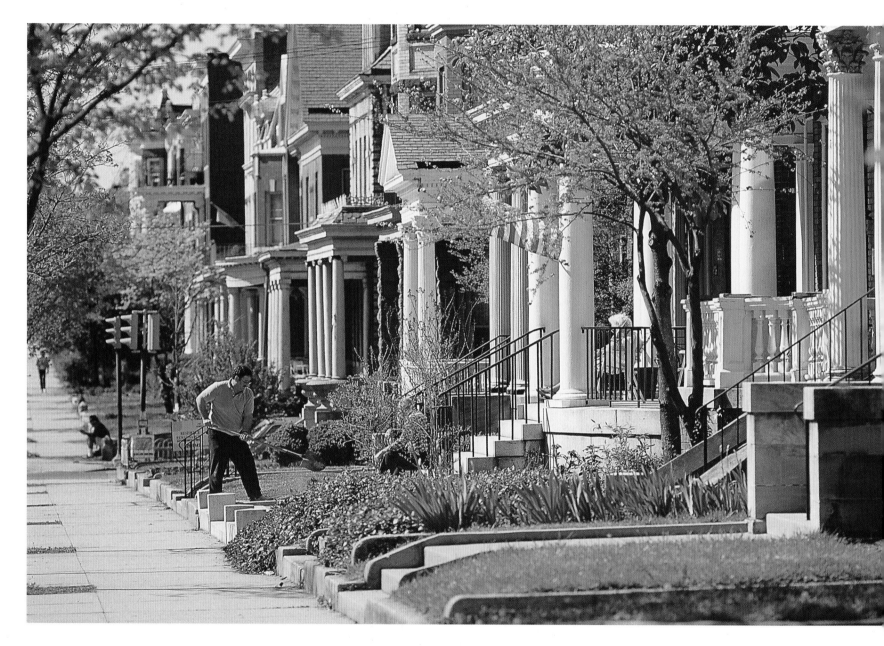

Historic apartment buildings and grand homes line Monument Avenue in Richmond. The street is named for six elaborate statues, from the Lee Monument, erected in 1890, to the Matthew Maury Monument, created in 1929.

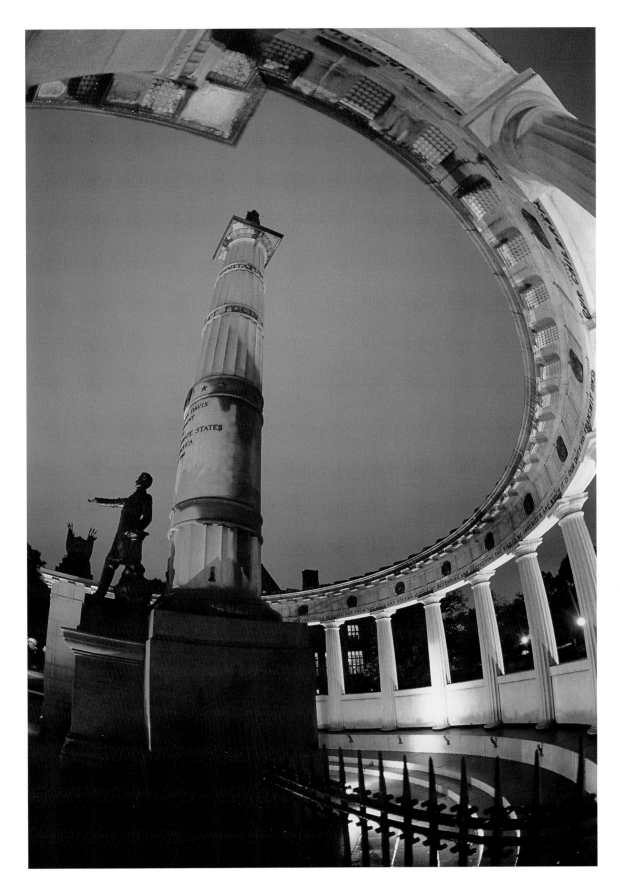

Five of the memorials along Monument Avenue commemorate leaders in the Civil War. The sixth—that of Arthur Ashe, added in 1996—honors the contributions of Richmond's best-known professional athlete and humanitarian.

Although best known for its population of ponies, Chincoteague National Wild-life Refuge was established to protect migratory birds along the Atlantic Flyway. Since it was founded in 1943, this has been one of America's most popular wildlife preserves.

FACING PAGE – Chincoteague National Wildlife Refuge, which encompasses 14,000 acres, is home to whitetail and sika deer, two herds of wild horses, herons, egrets, and waterfowl.

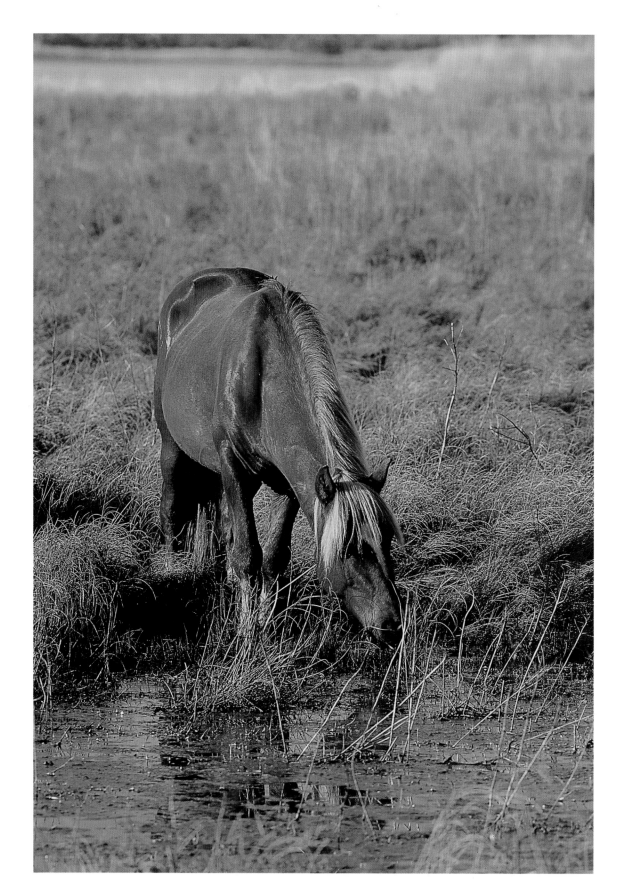

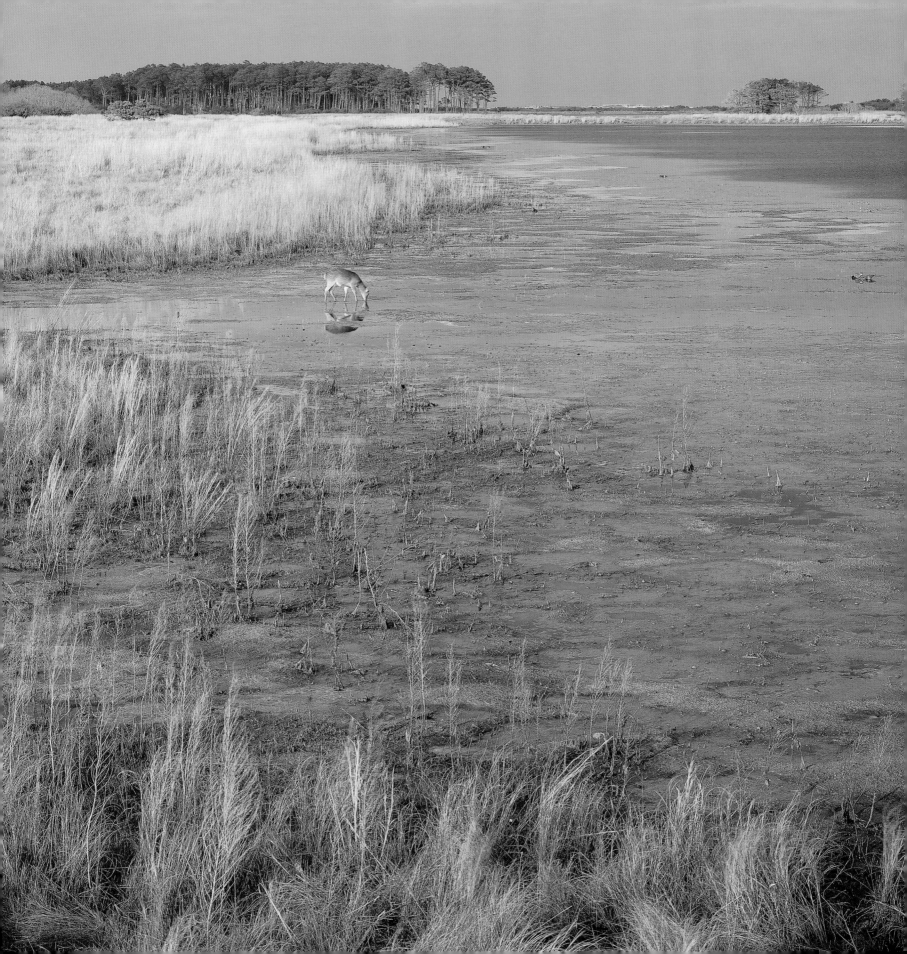

Assateague Island National Seashore was established in 1965 to protect this barrier island just off Virginia's coast. More than 2 million visitors flock to the preserve each summer to camp, canoe, or surf fish.

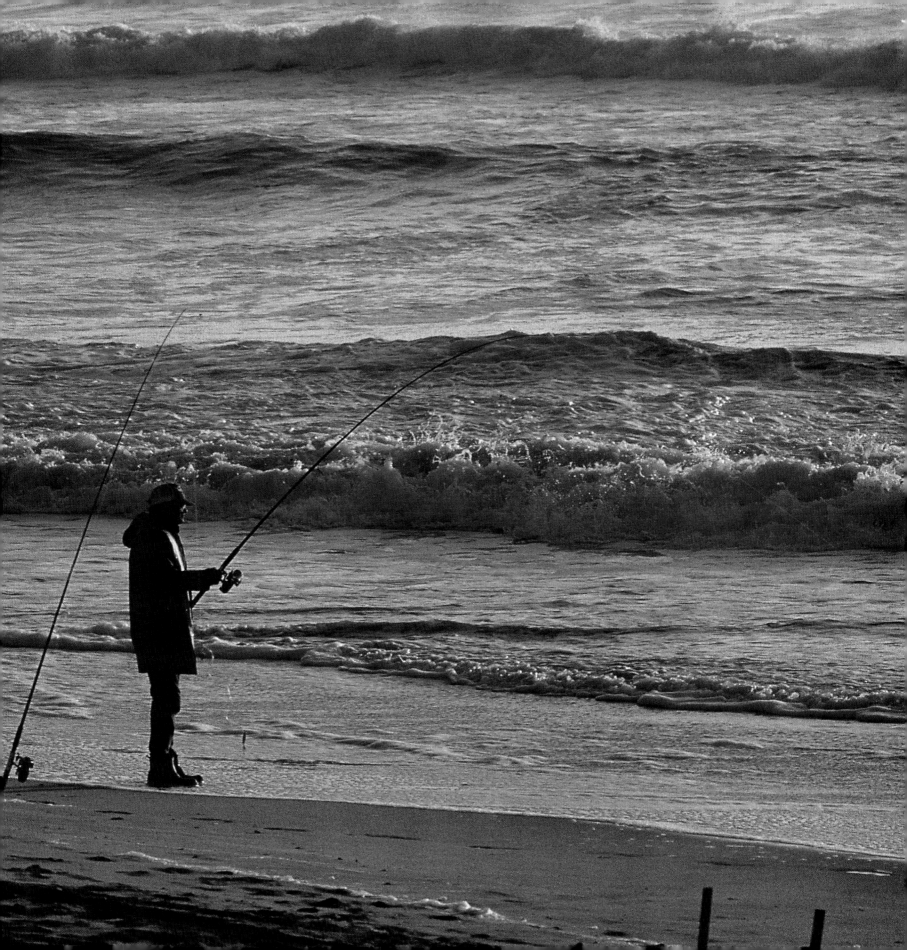

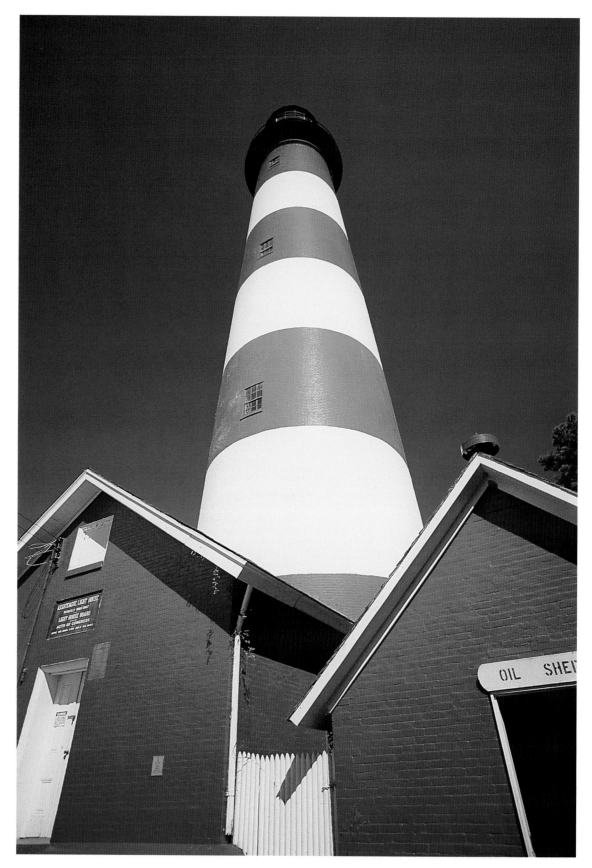

Built in 1867, the Assateague Island Lighthouse stands 142 feet tall. Unlike many lighthouses, threatened by erosion of the land around them, the Assateague beacon is moving slowly farther from the water, as tides and currents deposit more sand along the shore.

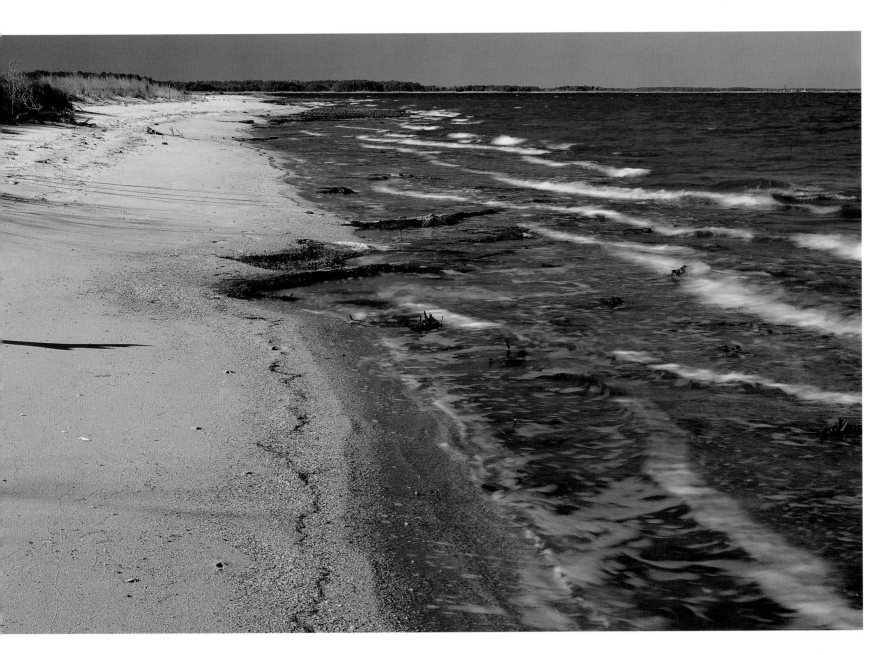

Hughlett Point Natural Area includes the tidal wetlands of a small peninsula in Chesapeake Bay. No part of the preserve reaches more than 10 feet above sea level. Otters, foxes, tundra swans, eagles, and osprey make their homes in the marshes.

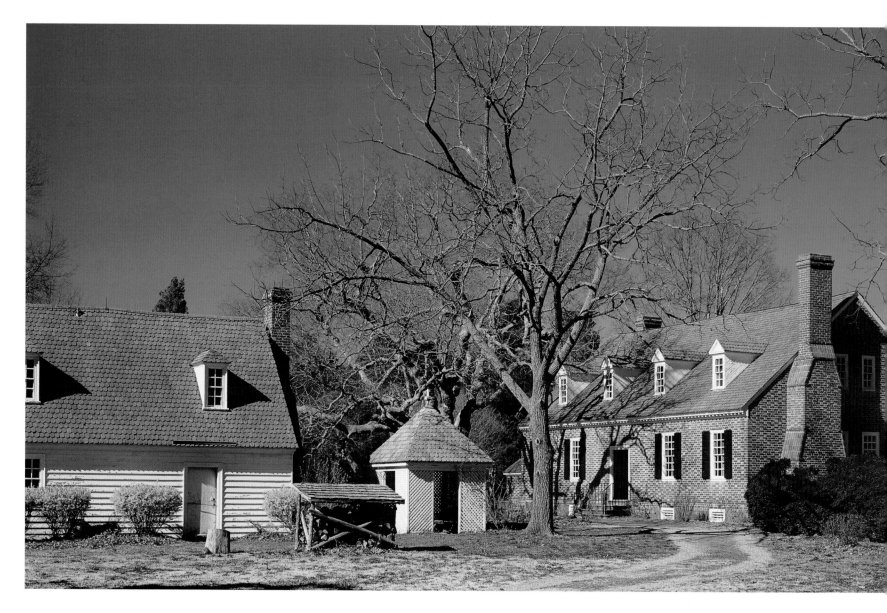

George Washington was born at Popes Creek Plantation—now George Washington Birthplace National Monument—in 1732. He lived here until he was three, and returned often throughout his youth. The monument includes several plantation buildings, a family cemetery, and an information center.

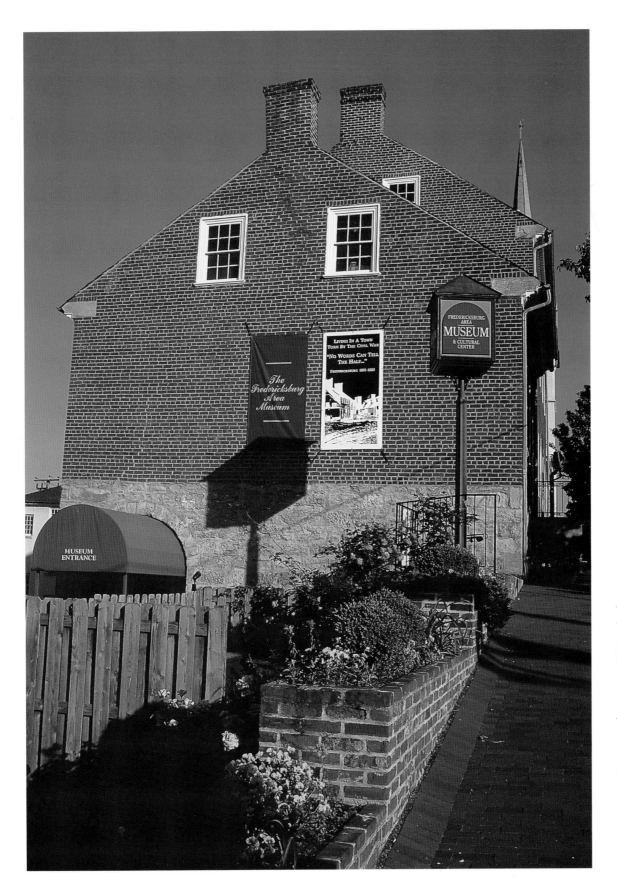

Fredericksburg is a peaceful sight today, but the area has seen more bloodshed than any other place in North America. About 110,000 men were killed in four Civil War battles near the town.

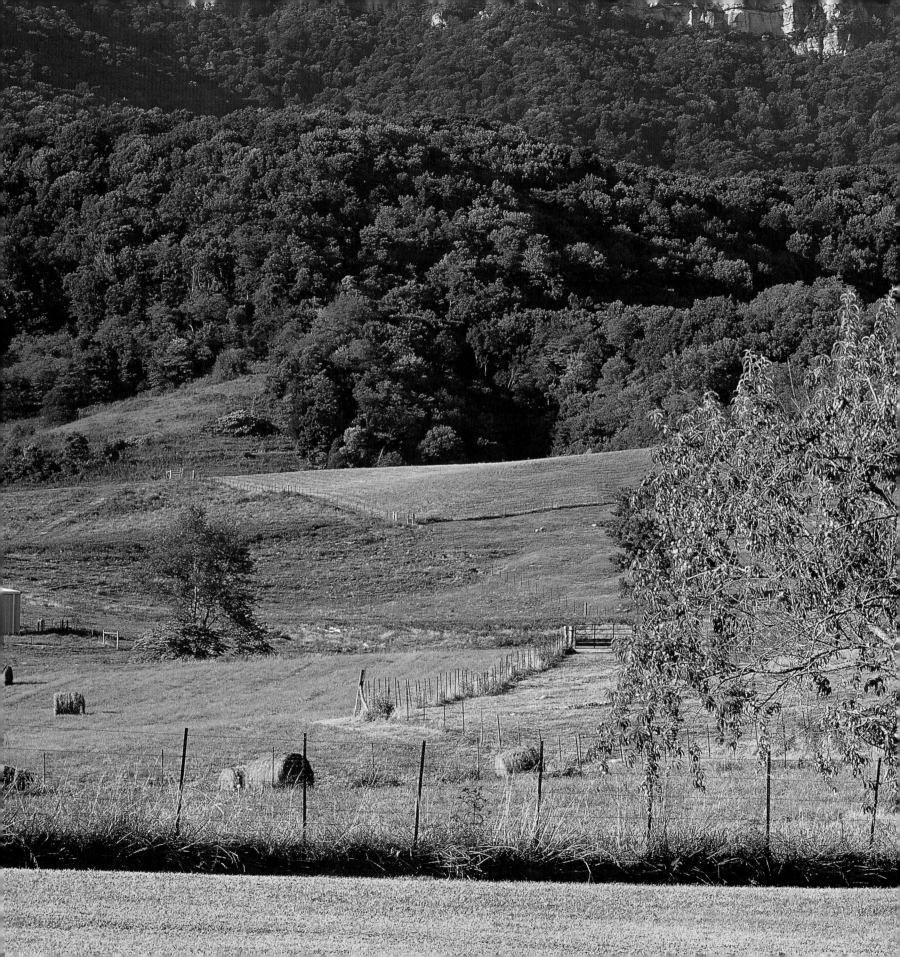

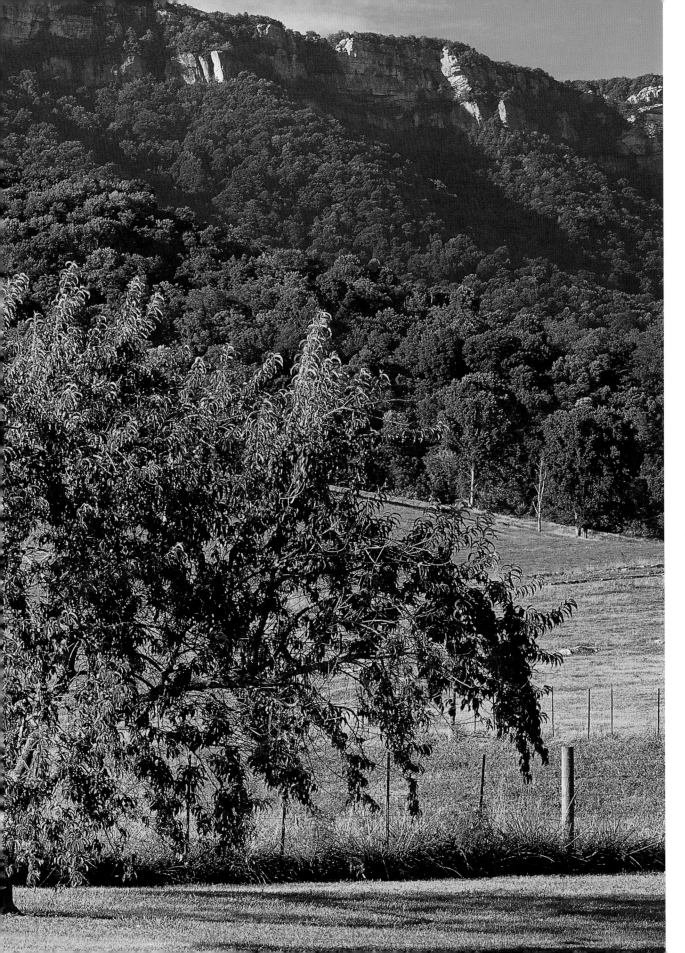

Virginia was one of the first 13 colonies to rebel against British rule and form the United States of America. Four of the foundling nation's first five presidents—George Washington, Thomas Jefferson, James Madison, and James Monroe—all hailed from Virginia.

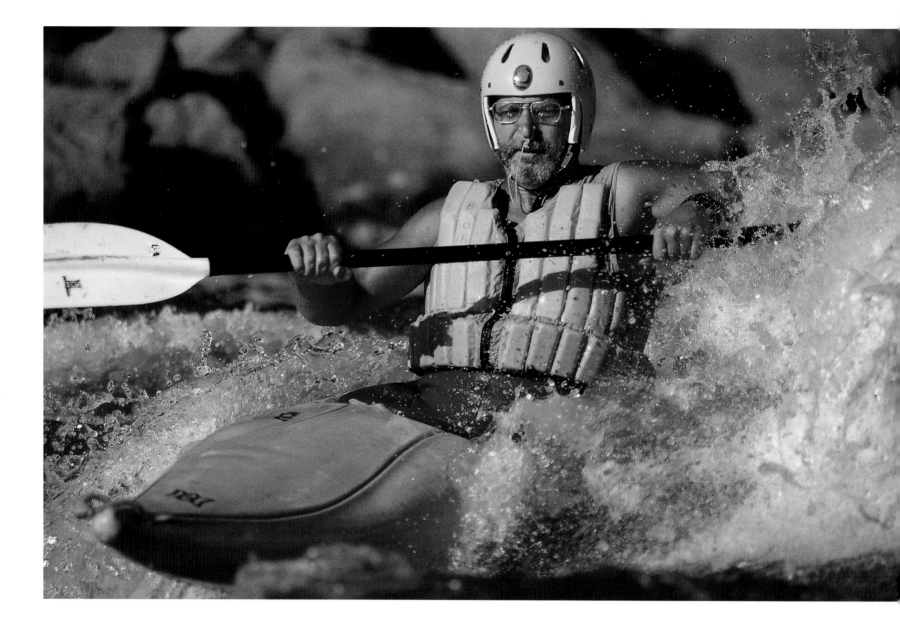

A kayaker challenges the Great Falls of the Potomac. The river drops a dramatic 76 feet in a series of falls and rapids protected by Great Falls Park in George Washington Memorial Parkway.

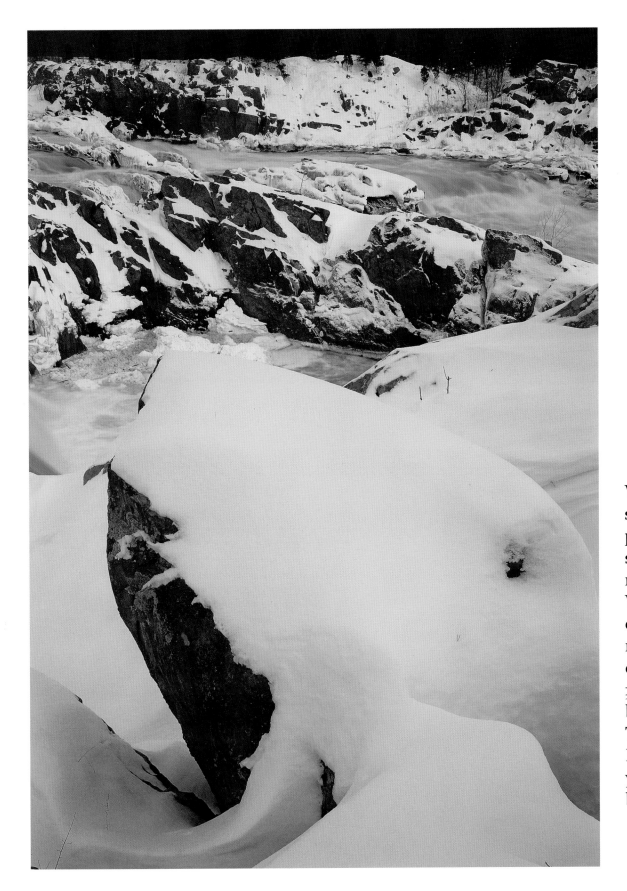

What is now a scenic stopping point was once a serious threat to navigation. George Washington and other leaders commissioned a series of canals in the late 1700s, hoping to bypass the rapids. The canal at Great Falls operated for 26 years, and can still be visited today.

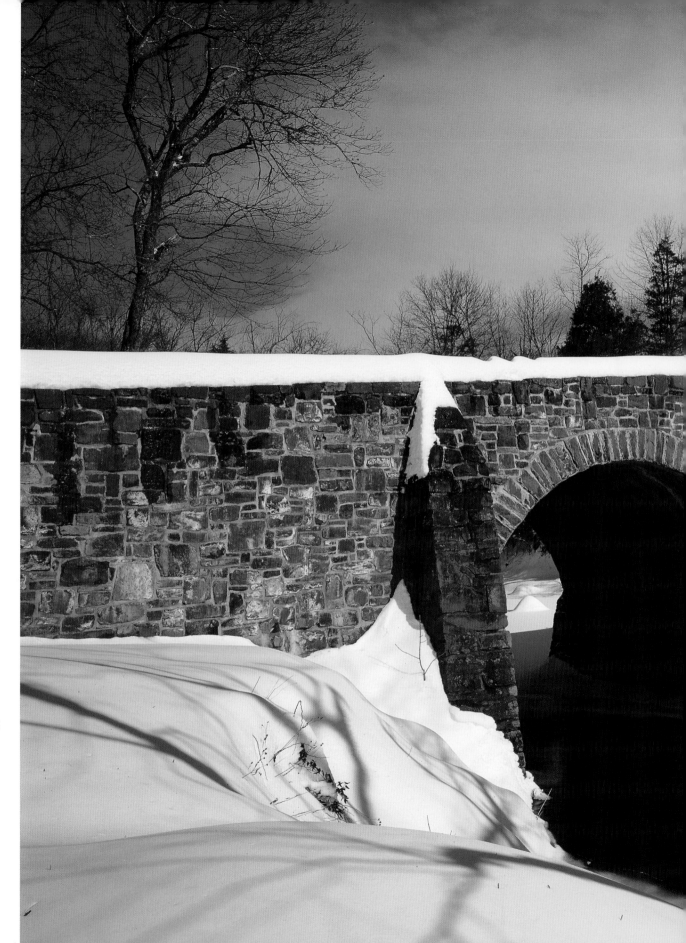

The Union and
Confederate armies
clashed at Manassas
twice, once in July,
1861, and again in
August, 1862. At
stake was the junc-
tion of the Orange &
Alexandria Railroad
and the Manassas
Gap Railroad, a stra-
tegic position for
either side.

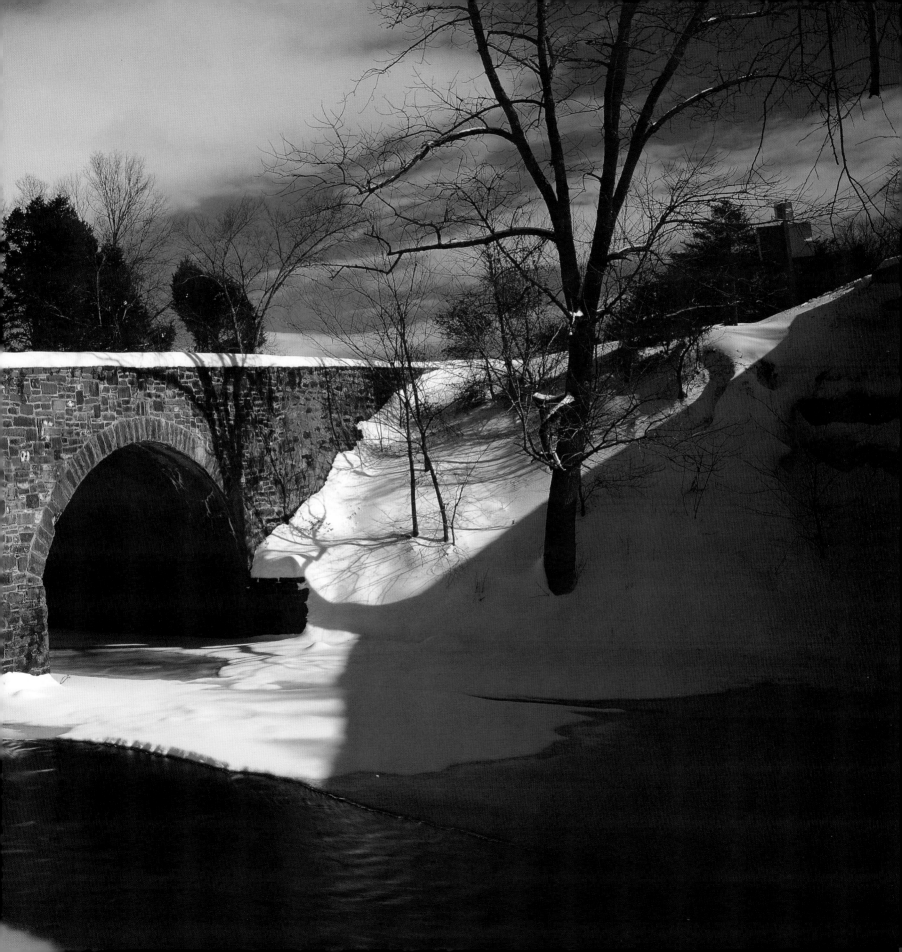

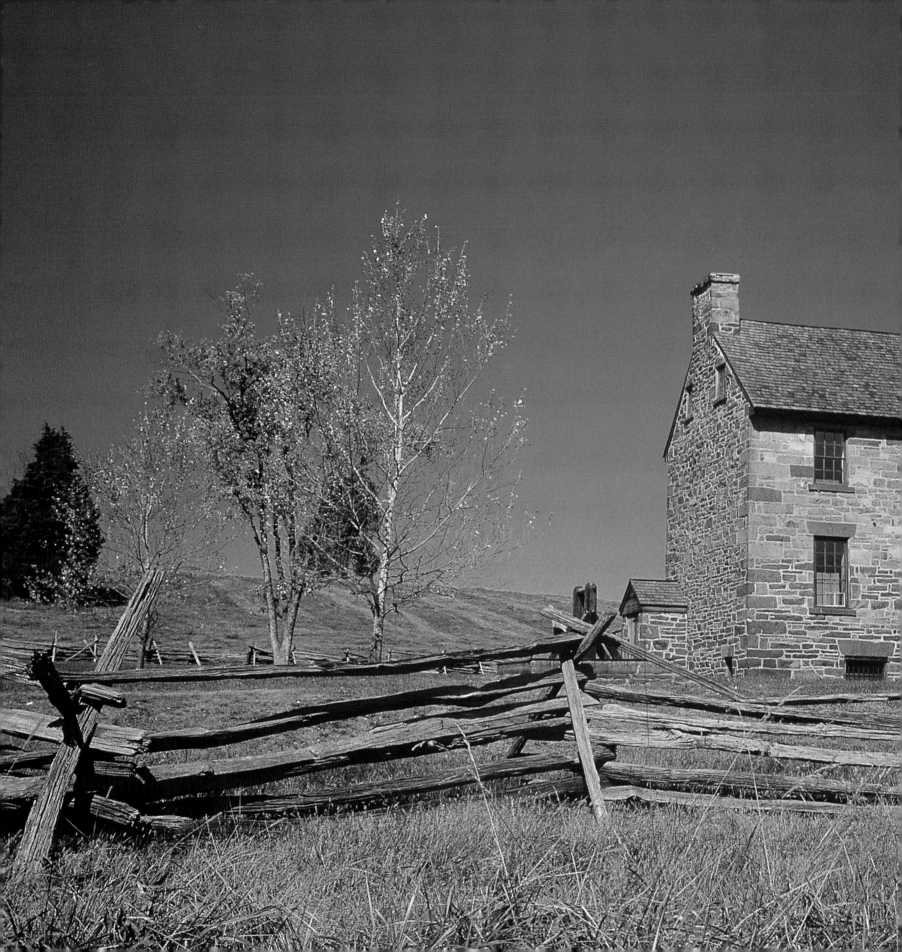

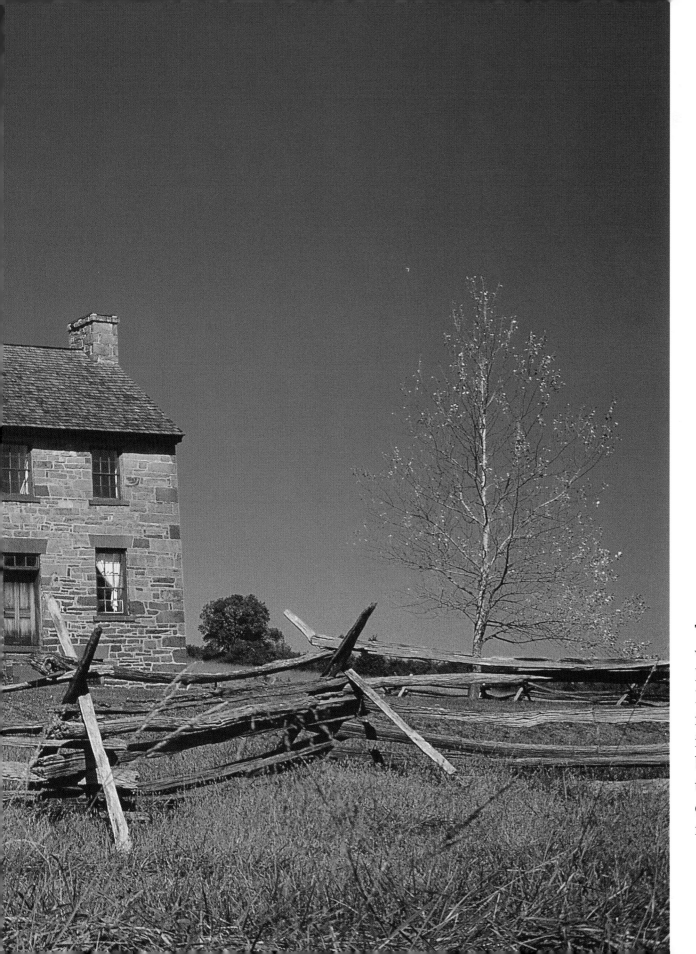

The Stone House within Manassas National Battlefield Park served as a field hospital during both historic battles. Shells from the fighting remain embedded in the red stone.

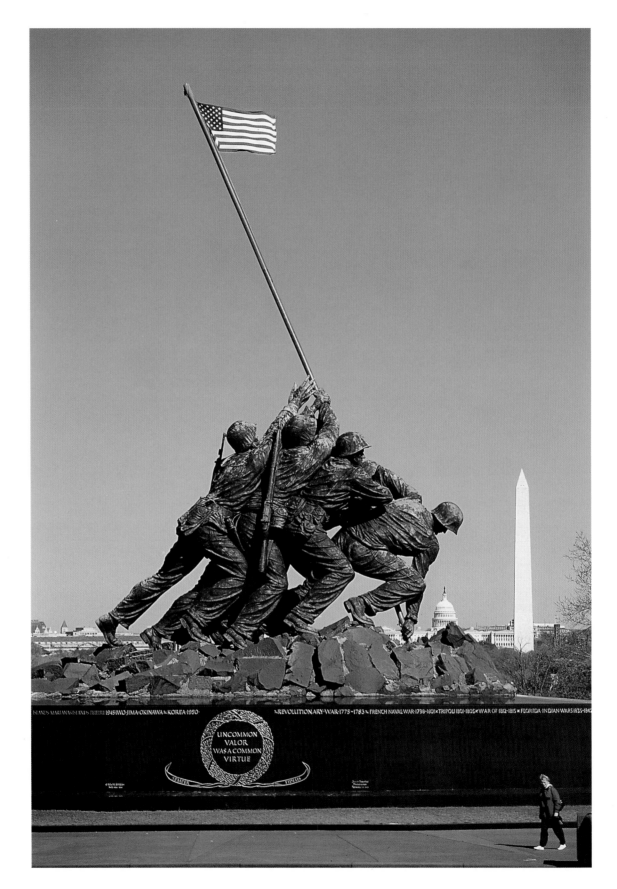

Home to about 200,000 people, Arlington serves mainly as a suburb of Washington, D.C. Fort Myer military post, the Pentagon, and Arlington National Cemetery all lie on this side of the Potomac.

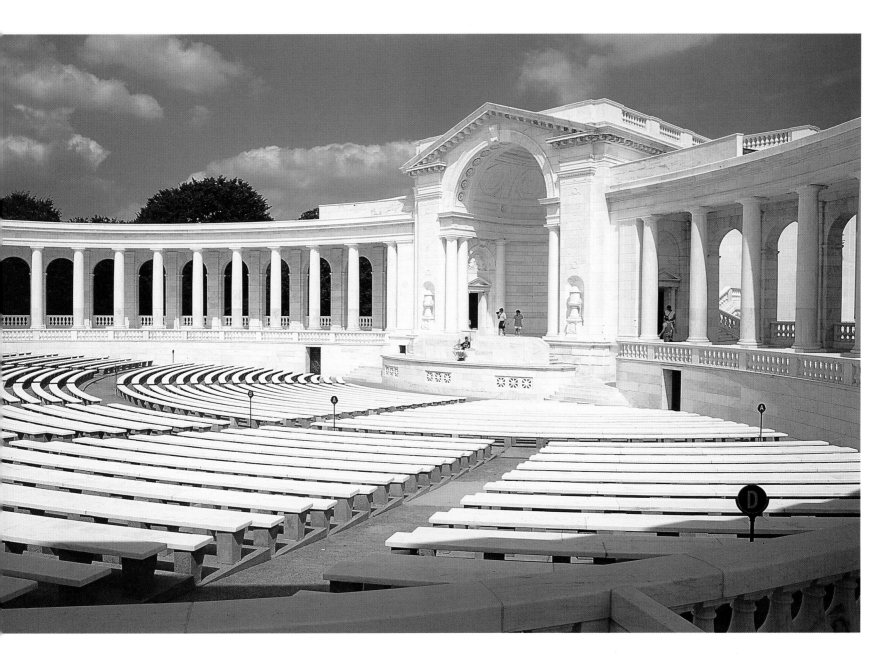

The Memorial Amphitheater in Arlington is best known as the site of the capital's Memorial Day services. Just across from the white marble risers, unknown soldiers from World Wars I and II, Korea, and Vietnam lay interred in the Tomb of the Unknowns.

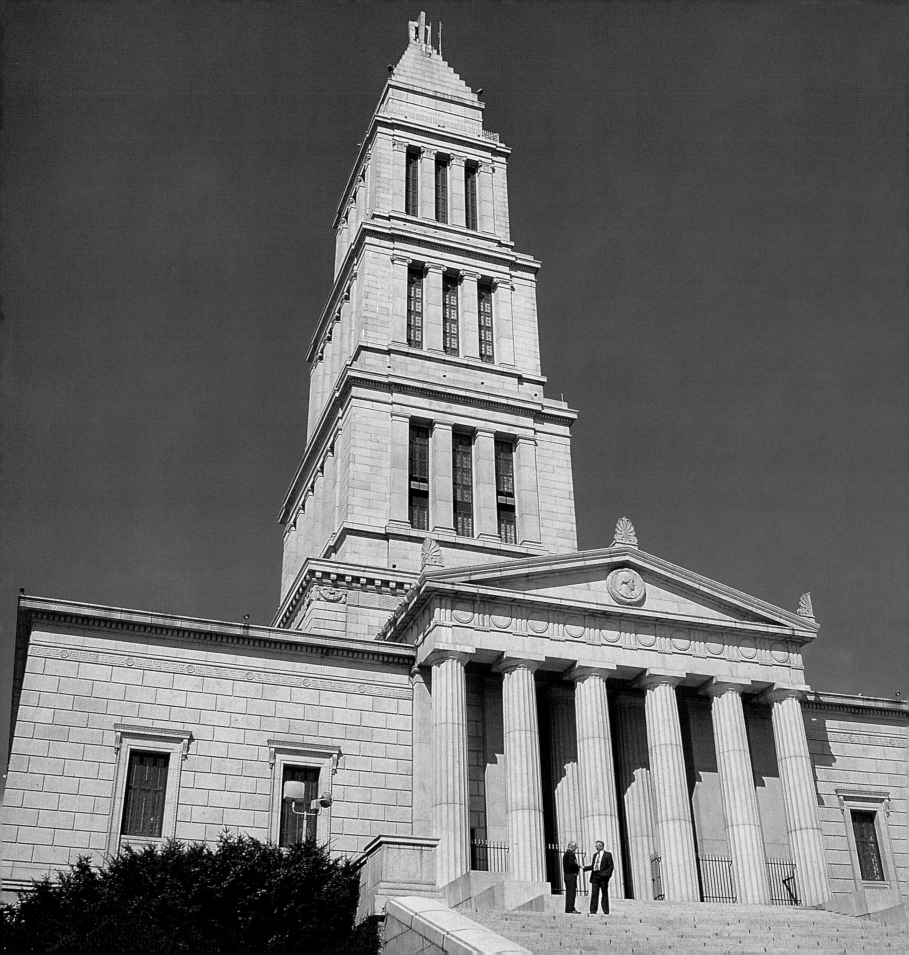

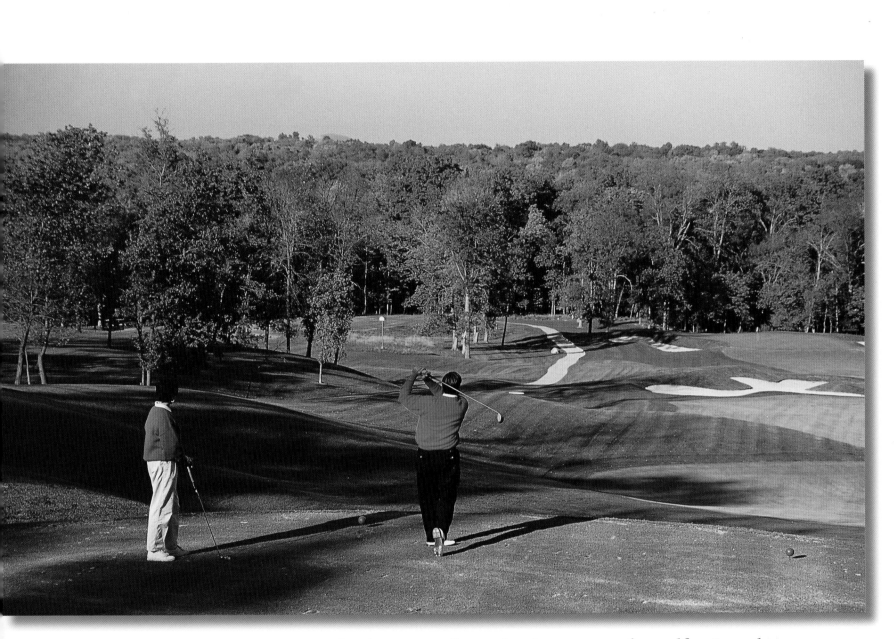

Business travelers take time out to play golf at Lansdowne Resort, overlooking the Potomac River. The resort offers luxurious rooms and award-winning conference facilities.

This towering granite memorial—the George Washington Masonic National Monument—holds historic artifacts from Washington's time, including the clock that a doctor stopped upon the leader's death.

Many of the buildings in Old Town Alexandria date from the seventeenth and eighteenth centuries, a time when prominent Americans such as George Washington kept homes in the city. Today, Alexandria offers vibrant shopping and nightlife along charming historic streets.

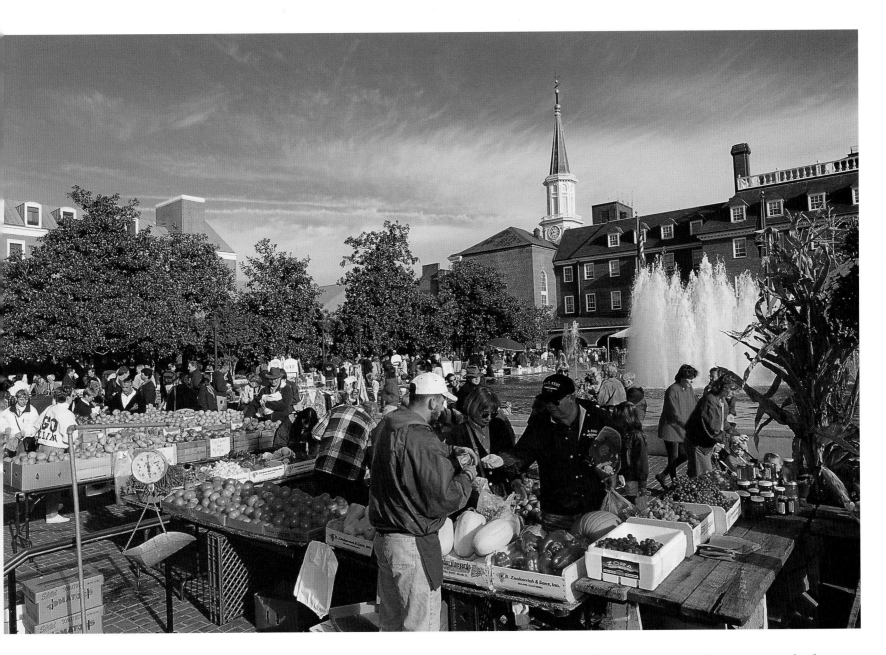

Plans for Alexandria's City Hall and the market square below were made in 1749, when Scottish merchants founded the port town. Architect Adolph Cluss designed a new city hall in the 1870s, after fire destroyed the original structure.

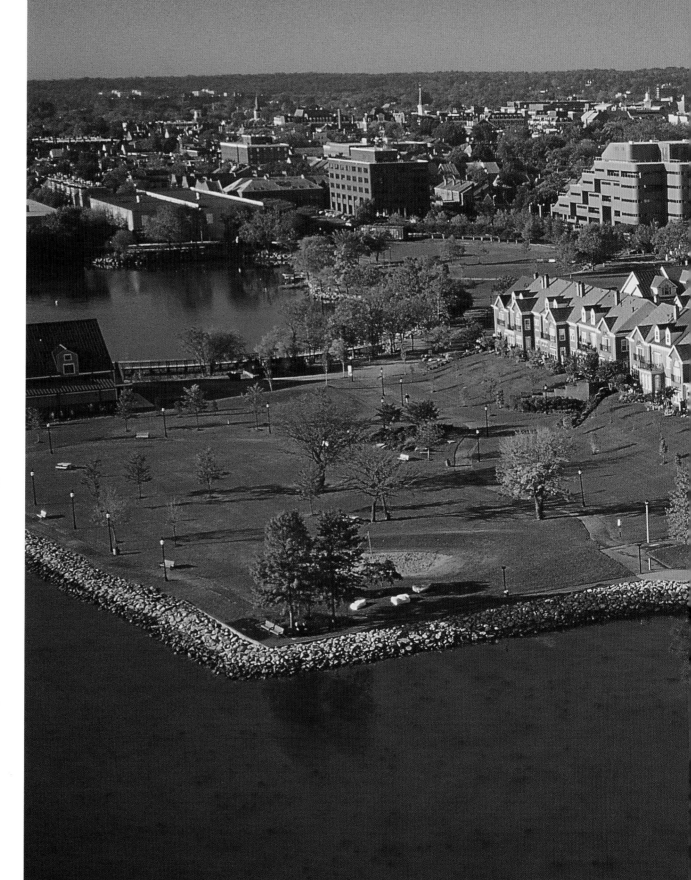

The original settlers named Alexandria in honor of John Alexander, who bought land in the area in 1669. The city's location on the Potomac River made it an important commercial port and a vital strategic point during the Revolu-tionary and Civil wars.

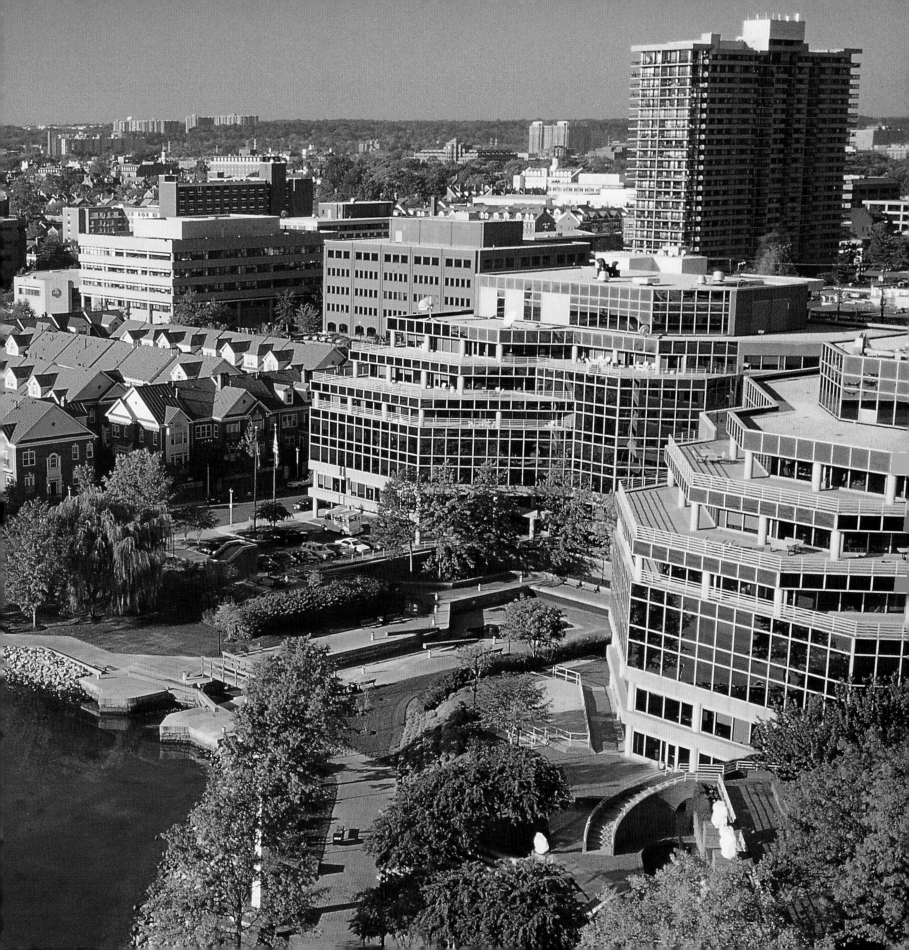

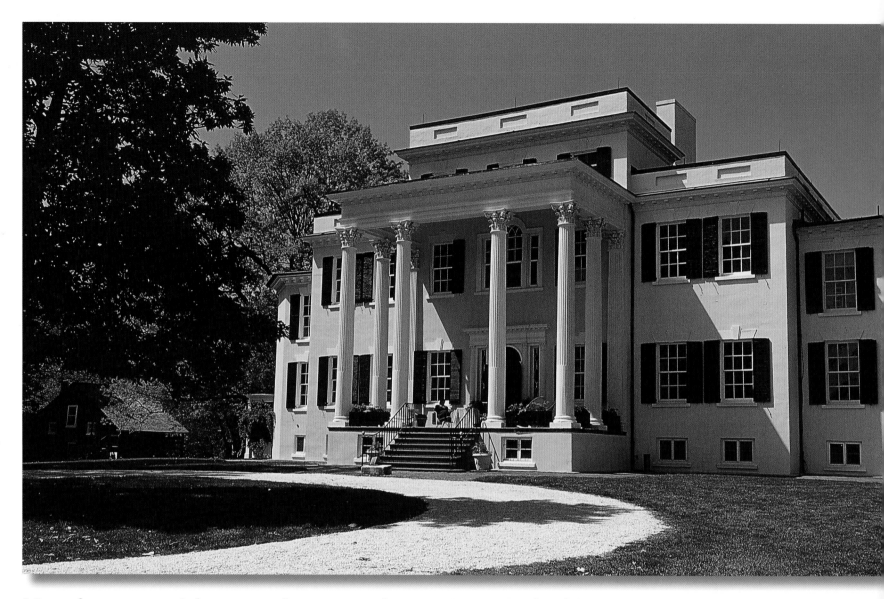

More than 70,000 sightseers each year tour the mansion at Oatlands Plantation near Leesburg. Now part of the National Trust for Historic Preservation, the home was established in 1803 by a great-grandson of one of Virginia's original settlers.

Architects Stewart Barney and Henry Otis Chapman created the ornate facades of John Handley Library in Winchester after Judge Handley gave more than a million dollars to the project in 1895.

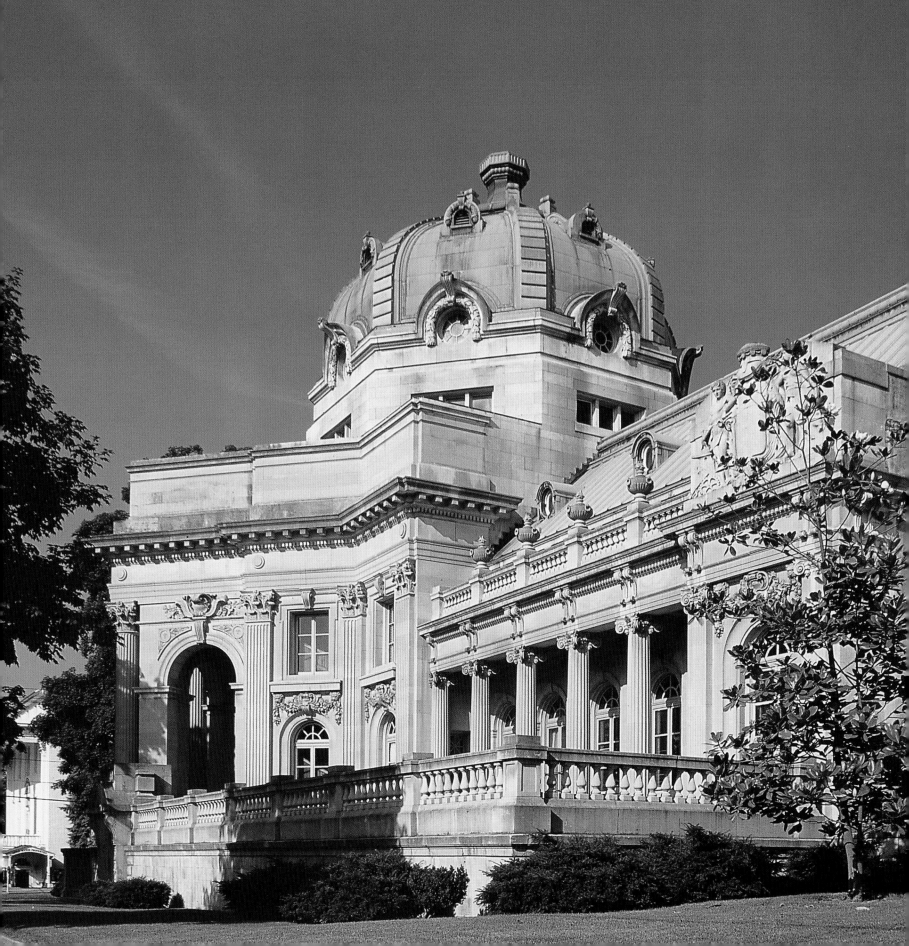

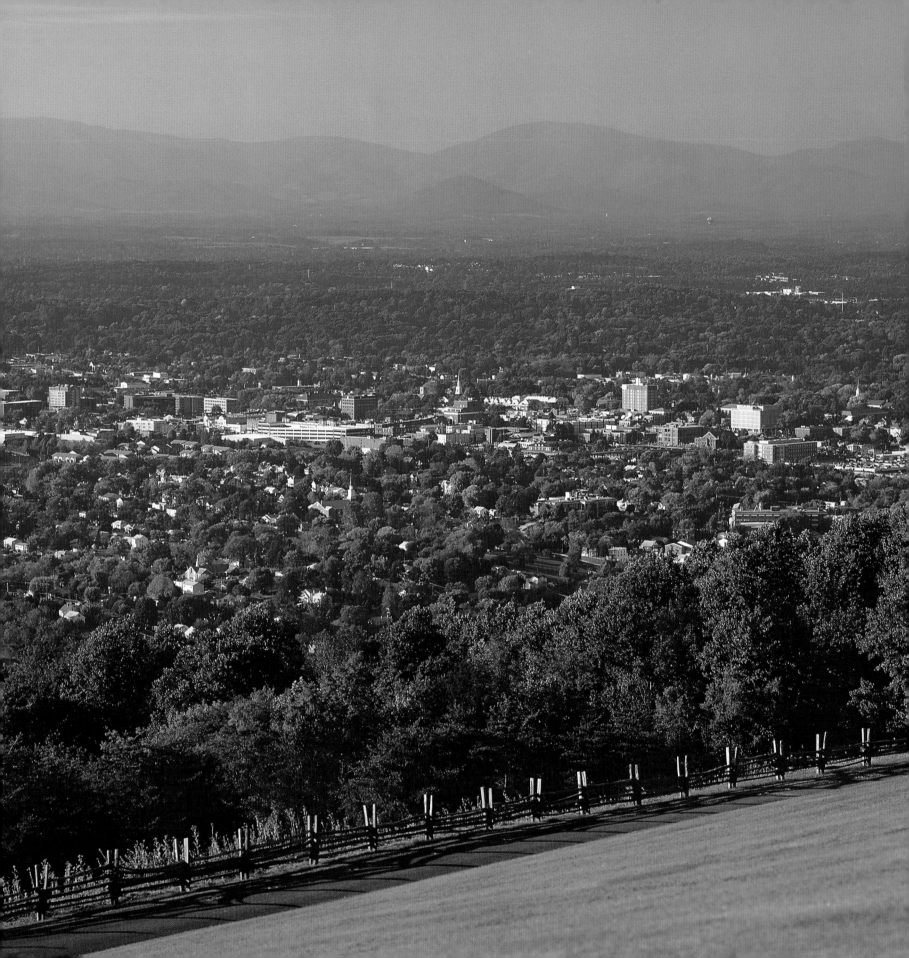

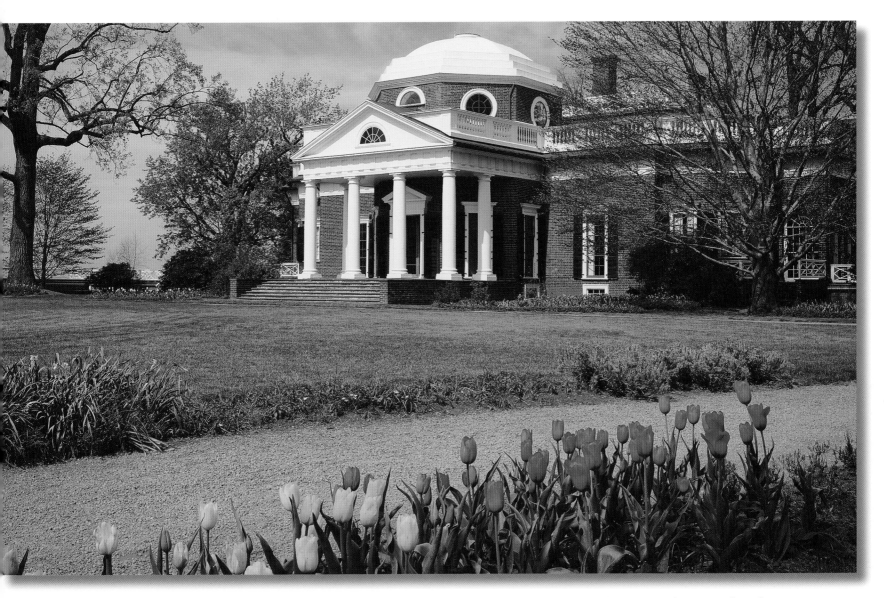

Thomas Jefferson once wrote, "All my wishes end, where I hope my days will end, at Monticello." Jefferson designed the 33-room estate in 1769, and he continued to renovate until his death in 1826.

Nestled in the foothills of the Blue Ridge Mountains, Charlottesville is home to more than 40,000 people, including a thriving population of authors. The Virginia Festival of the Book attracts thousands of readers and writers to the city each year.

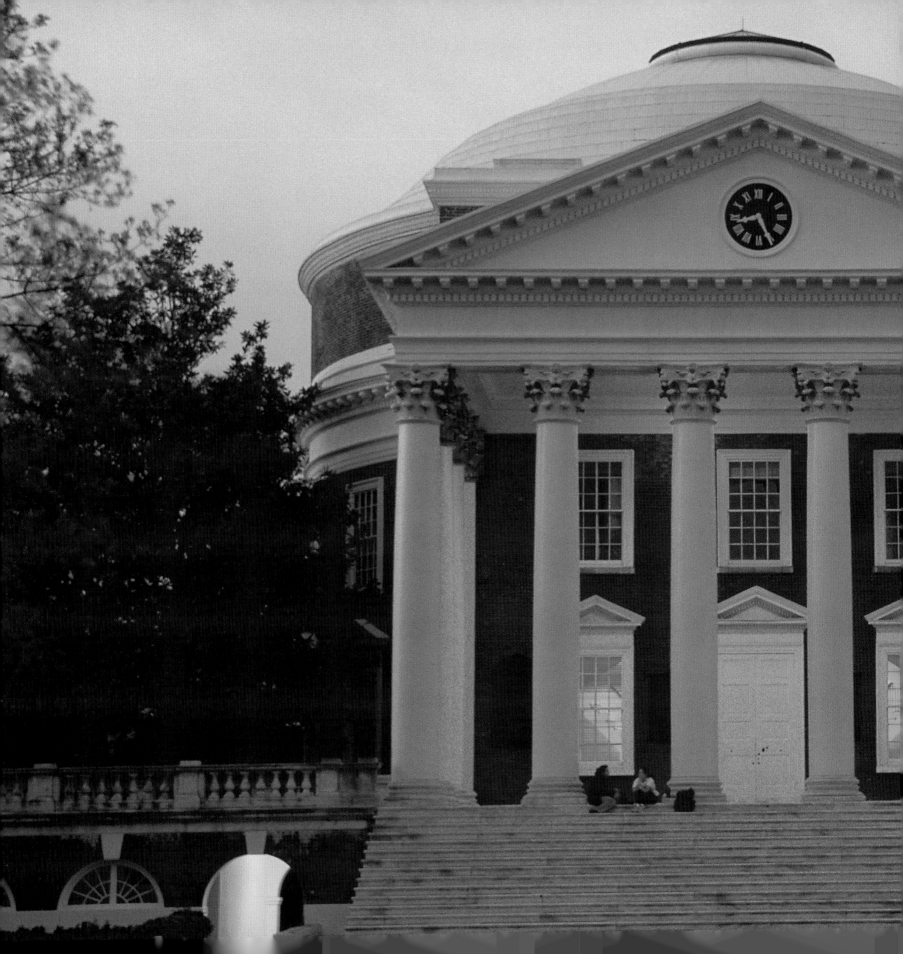

Thomas Jefferson founded the University of Virginia in Charlottesville in 1819; the school awarded its first degree in 1828. More than 18,000 students now attend classes here.

In the 1980s, a dedicated group of local citizens saved Poplar Forest, an estate once owned by Thomas Jefferson near Lynchburg. They raised funds and purchased 500 acres of land and began rebuilding the original manor house.

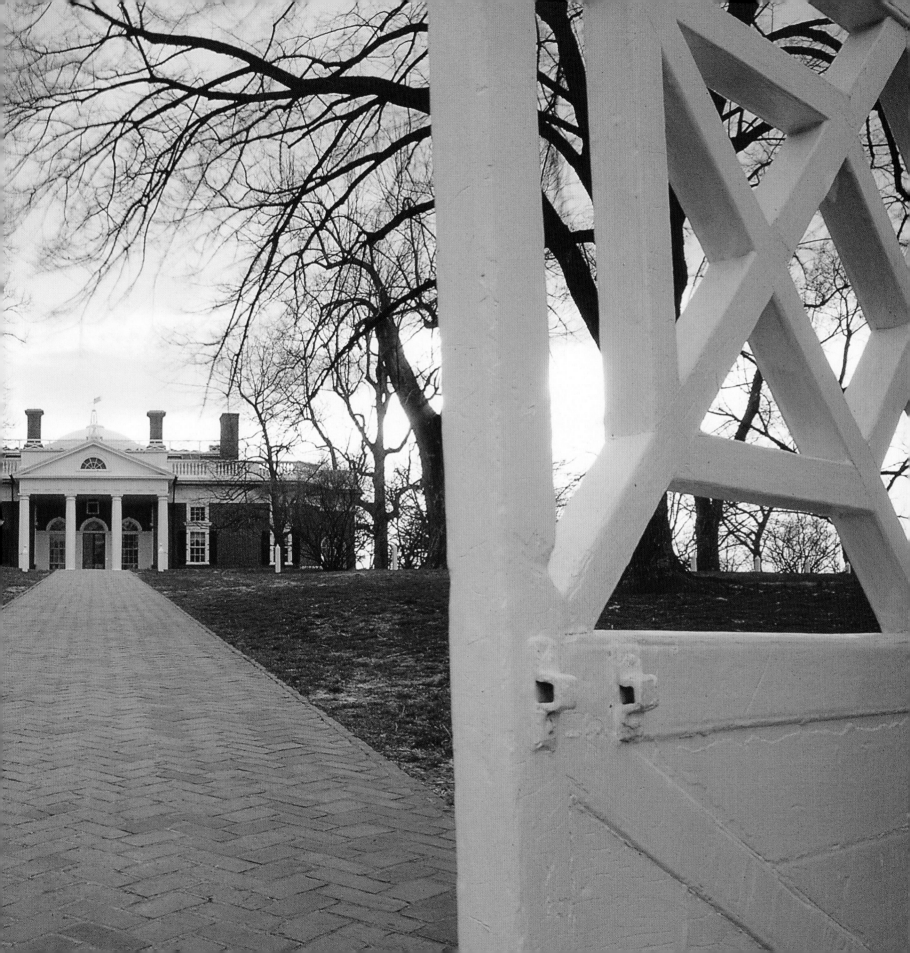

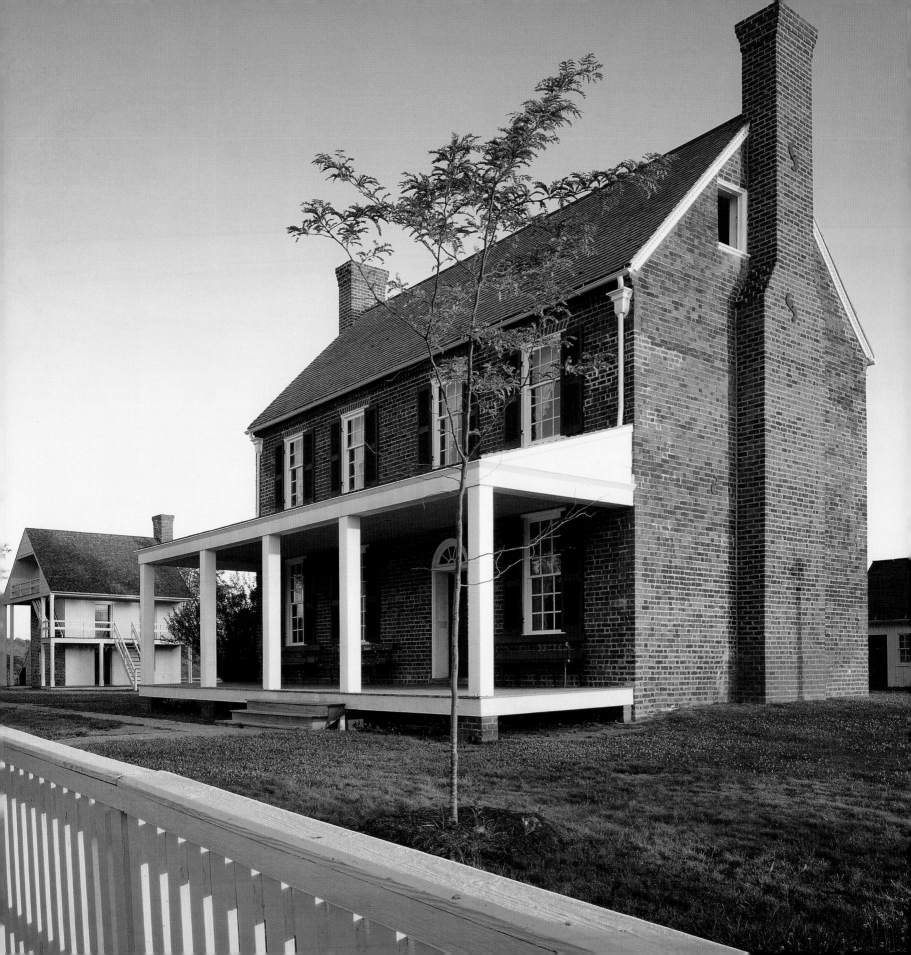

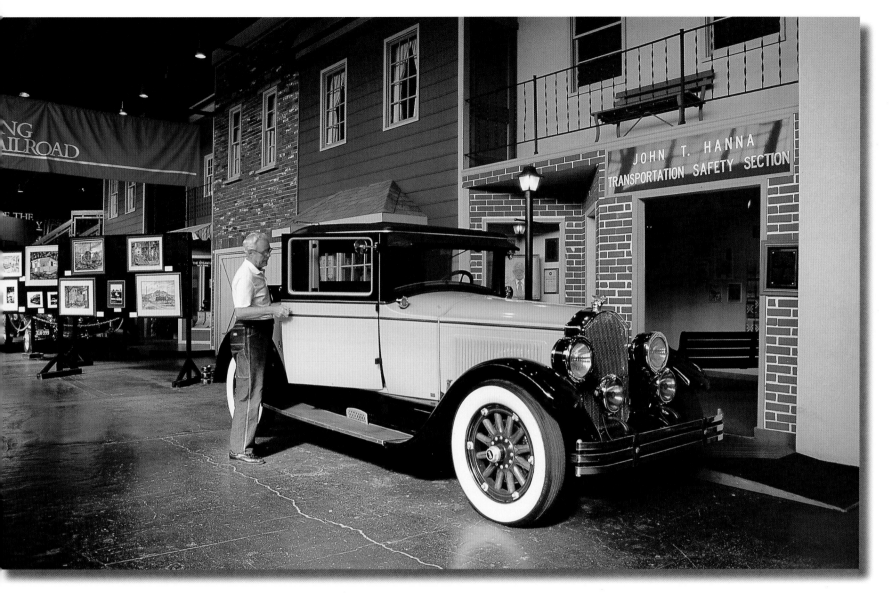

The Virginia Museum of Transportation in Roanoke traces the history of automobiles and railways throughout the world. Featured exhibits include a Model T Ford and a Panama Canal Electric Towing Locomotive.

In 1865, General Robert E. Lee surrendered his forces to General Ulysses S. Grant at Appomattox Court House, now a national historic park. With Lee's surrender, the southern states had failed in their attempt to create their own nation, and the war was over.

Born a slave in 1856, Booker T. Washington later became a renowned educator. He believed that if former slaves achieved education and economic success, increased civil rights would follow.

FACING PAGE –
More than 22,000 people each year tour Booker T. Washington's birthplace, protected as a national monument since 1956. Washington's family left this 27-acre tobacco farm after the Emancipation Proclamation of 1865.

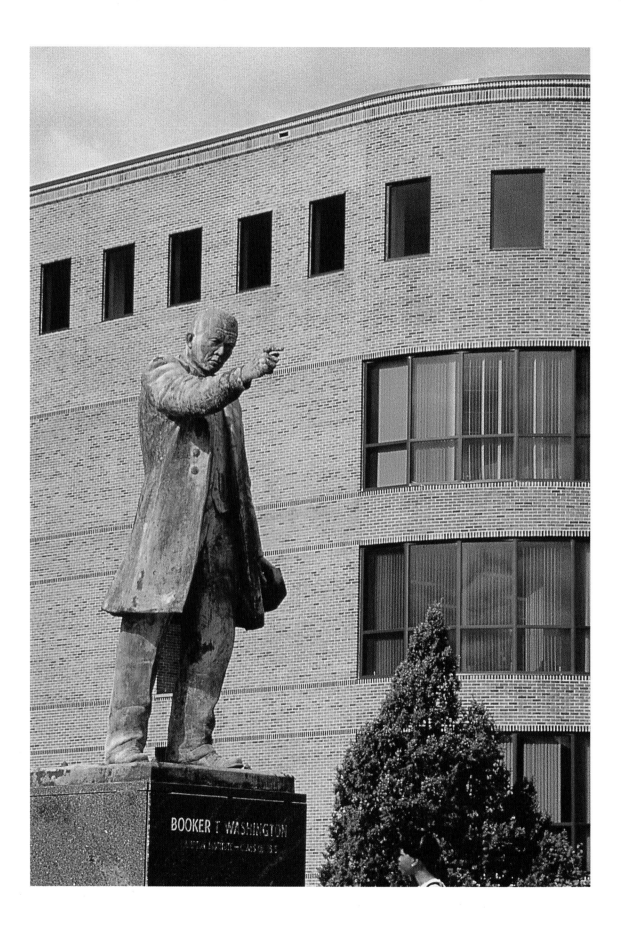

BOOKER T WASHINGTON

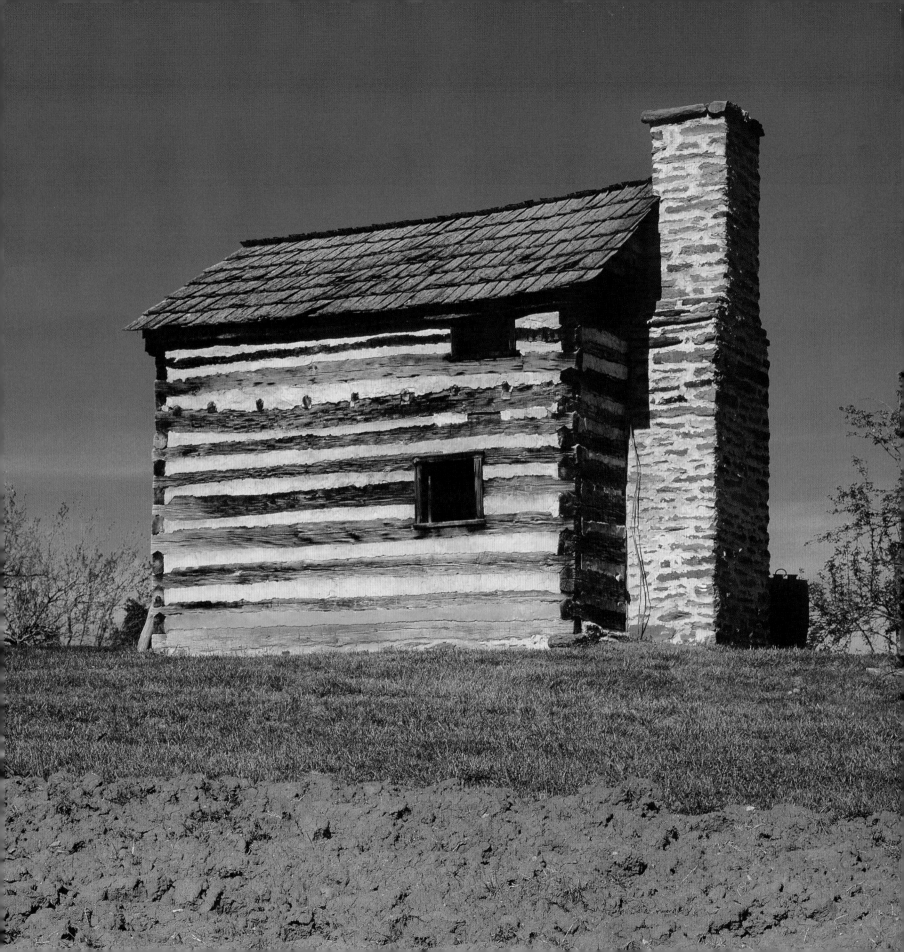

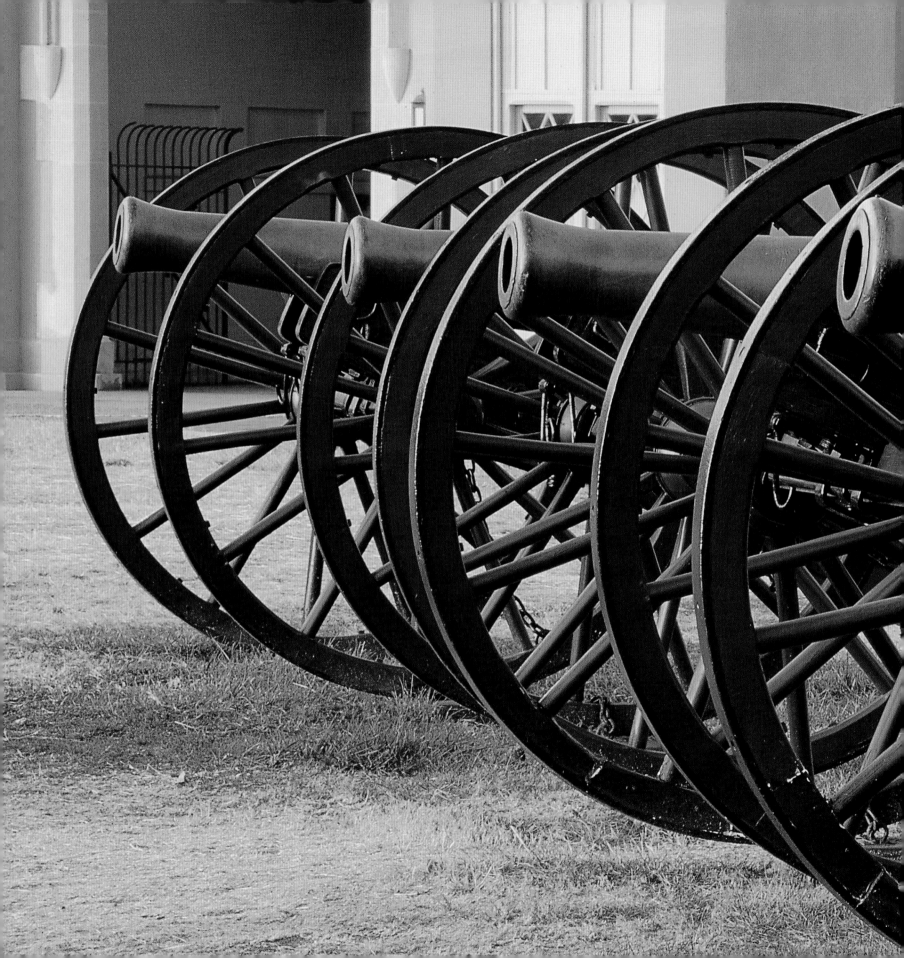

The oldest state-supported military college in the country, the Virginia Military Institute opened its doors in 1839. With a strict honor code and military discipline, the school endeavors to create leaders for all aspects of society.

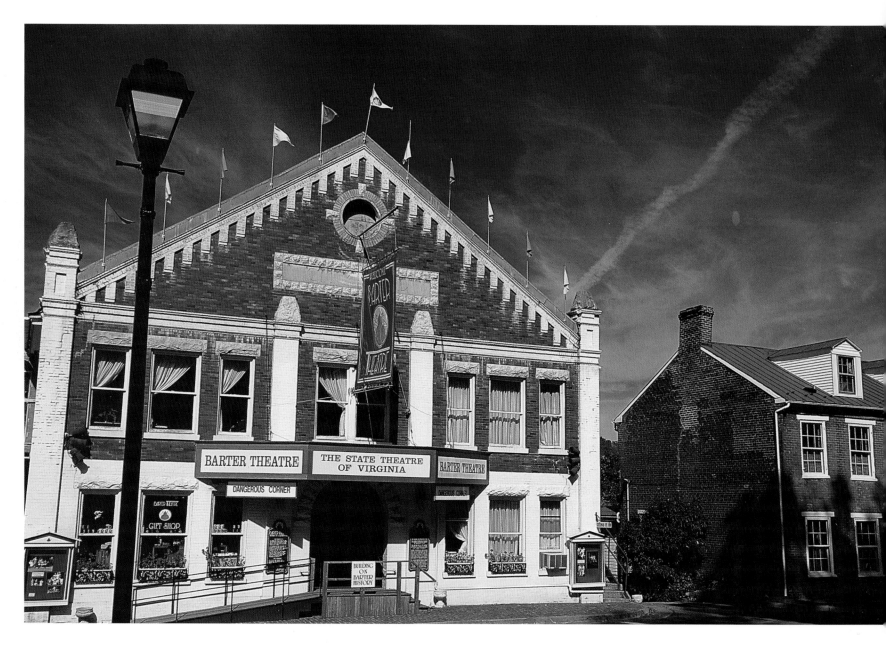

The town of Abingdon, in the shadow of the Blue Ridge
Mountains, stands on the site where Daniel Boone was once
attacked by wolves. Visitors here often attend a show at the
Barter Theatre, a professional performance venue that has
launched actors such as Gregory Peck and Patricia Neal.

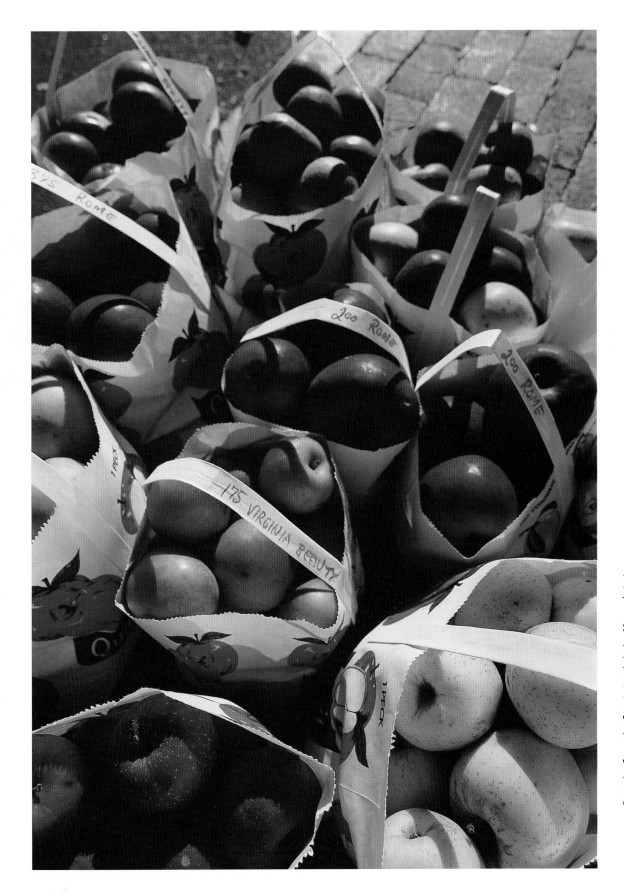

More than 250 Virginia growers specialize in apples, producing more than 14 varieties. Exported to 15 states and 20 countries, the fruit contributes about $235 million to the state's annual economy.

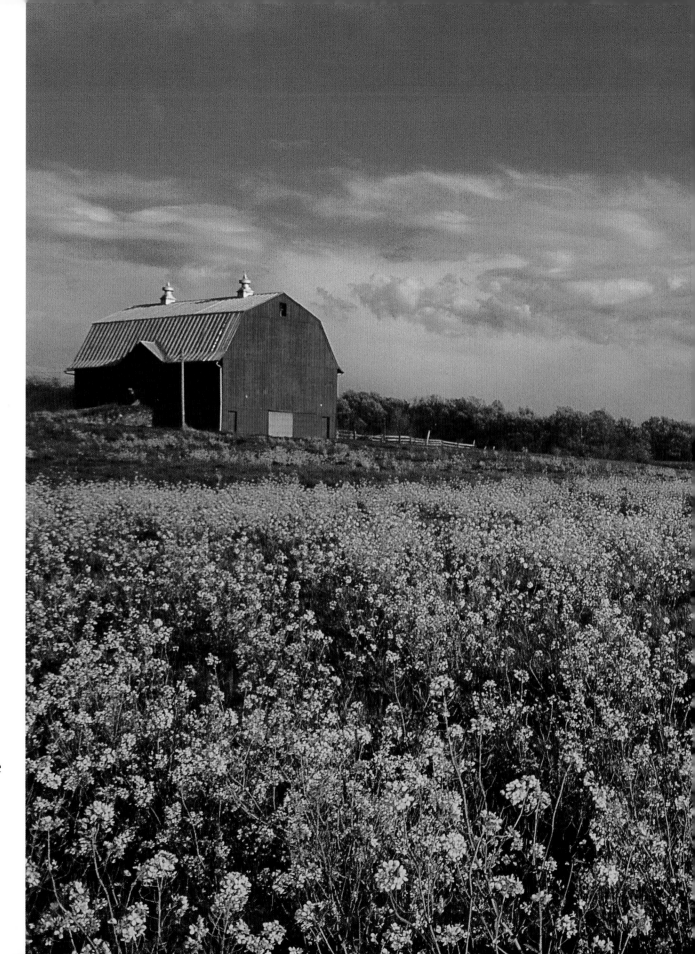

Almost 50,000 farms in Virginia produce a wide range of products, from tobacco to pork. Agricultural land makes up more than 30 percent of the state—8.8 million acres.

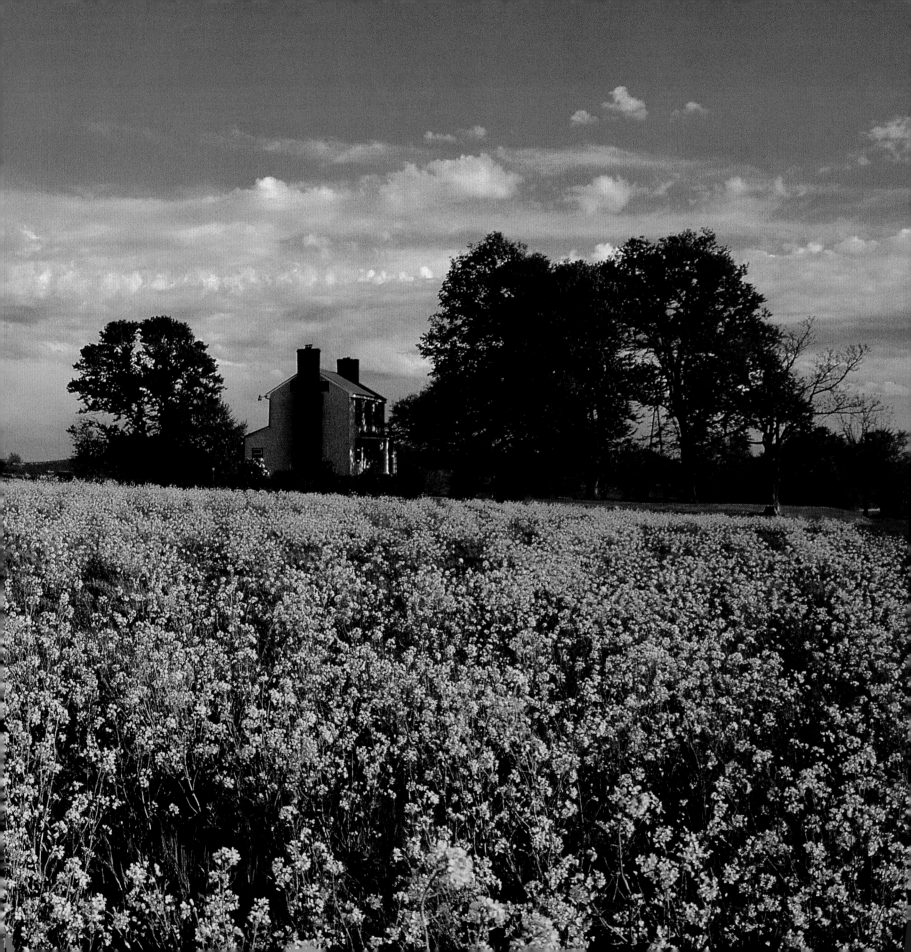

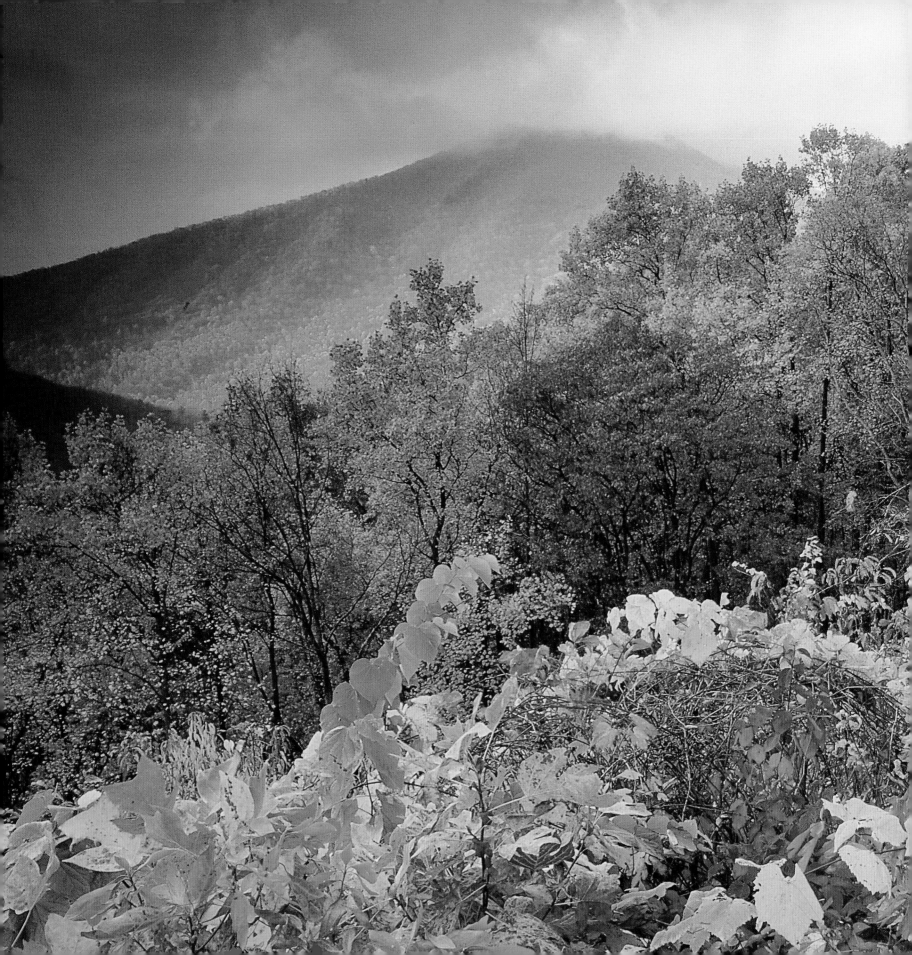

Protecting 300 square miles of the Blue Ridge Mountains, Shenandoah National Park includes peaks that tower more than 4,000 feet high, thickly forested valleys, and the headwaters of three of Virginia's nine watersheds.

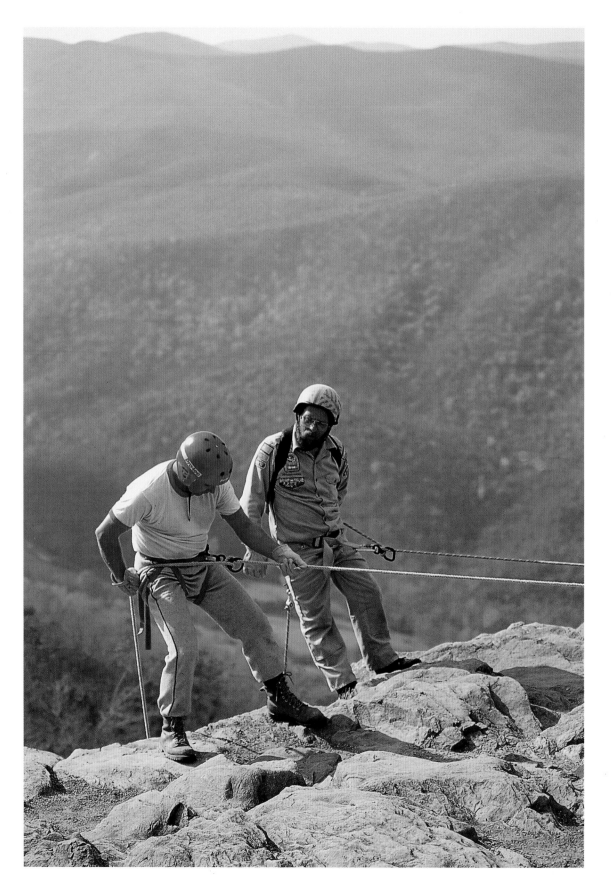

Geologists believe that the Blue Ridge Mountains may once have towered as high as the Himalayas. Epochs of erosion have worn down the peaks— some of the rock here dates from more than a billion years ago.

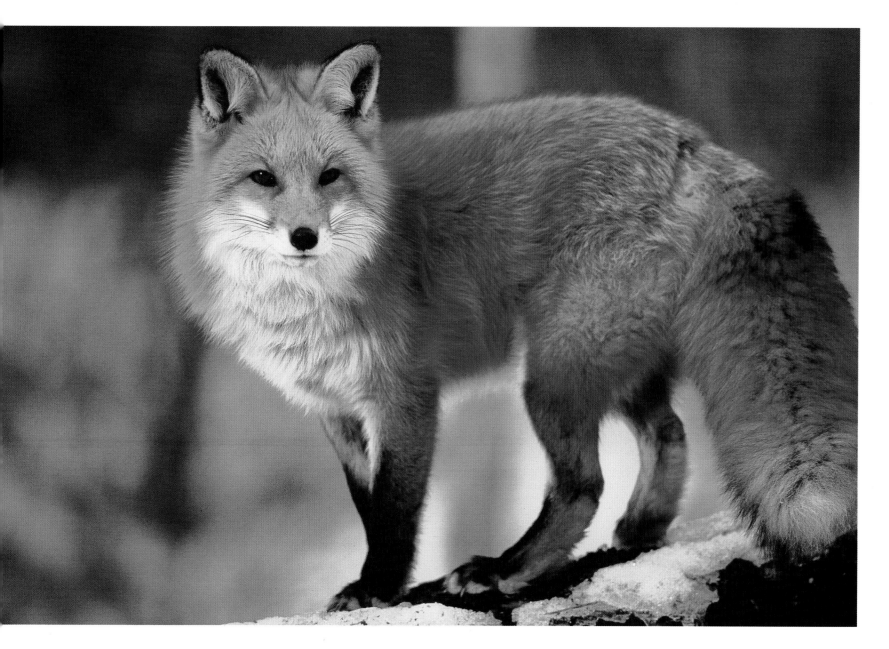

Shenandoah National Park protects complex ecosystems that are home to animals ranging from foxes and tiny shrews to black bears and bobcats. Endangered species within the park include the Shenandoah salamander, the winter wren, and the Blackburnian warbler.

There are more than 500 miles of trails through Shenandoah National Park. They range from short strolls to multi-day backpacking excursions, and include a 101-mile portion of the Appalachian National Scenic Trail.

FACING PAGE –
The lush greens of the hardwood forests in spring form a panoramic view below Skyline Drive. More than 75 viewing points line the 105-mile route through Shenandoah National Park.

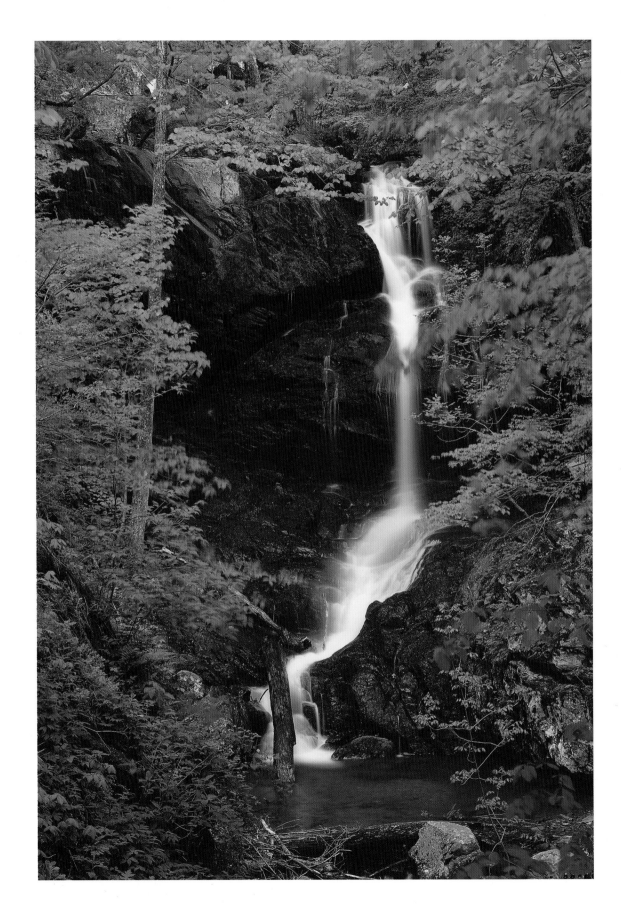

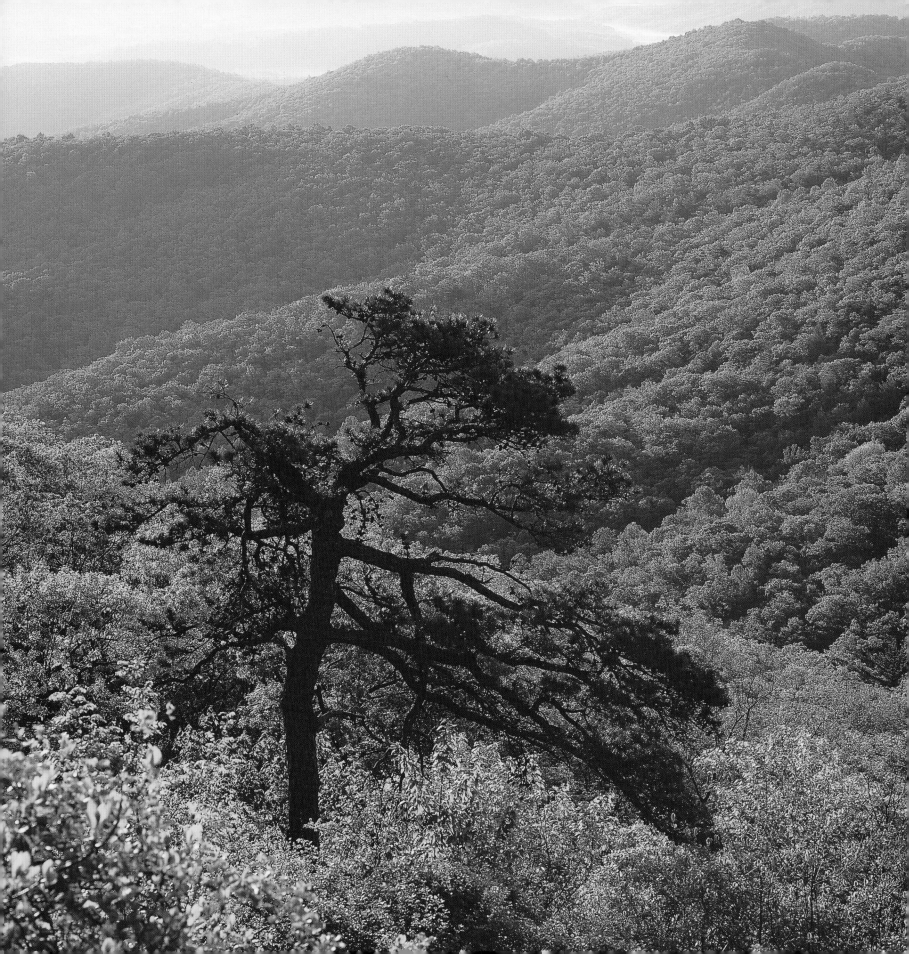

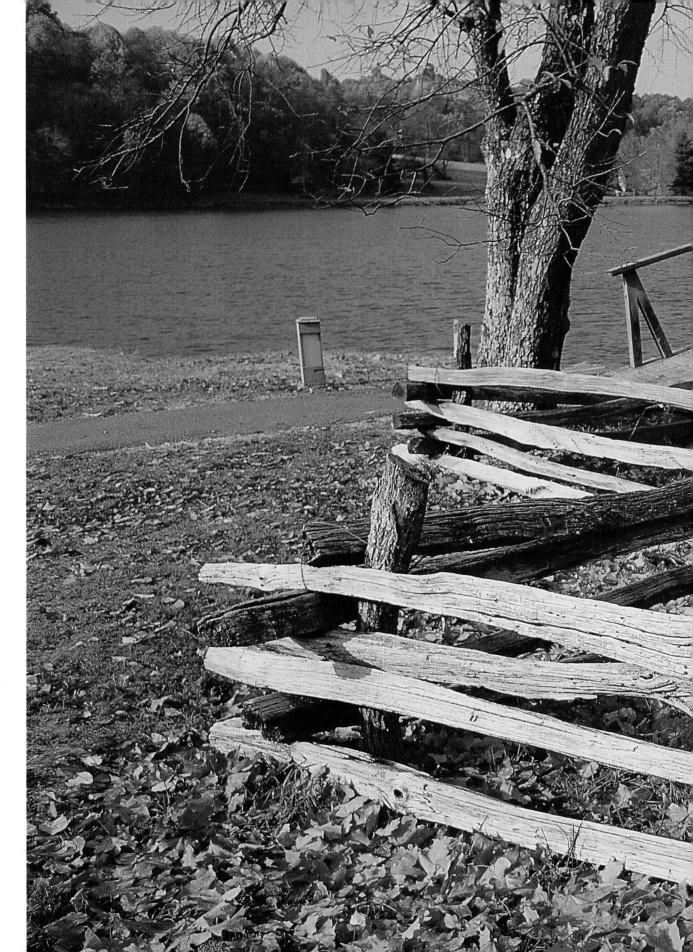

Connecting
Shenandoah
National Park
with Great Smoky
Mountains National
Park in North
Carolina, the Blue
Ridge Parkway
winds through wil-
derness slopes and
mountain valleys
for 469 miles.

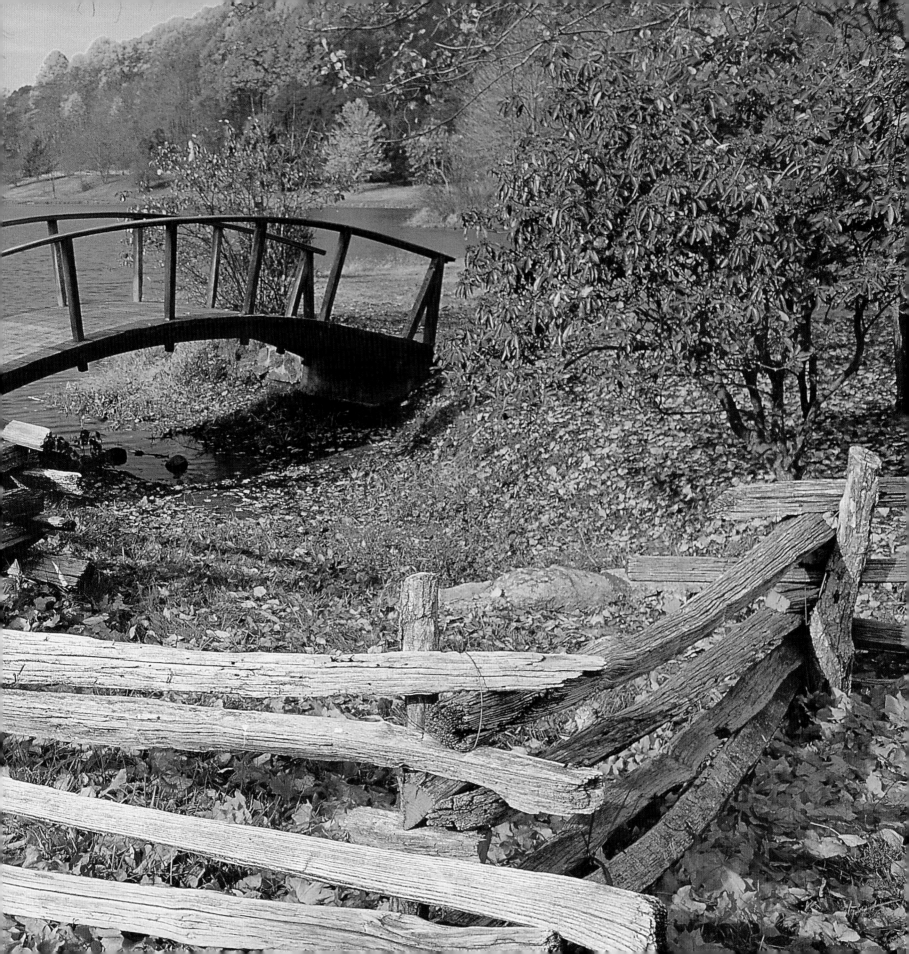

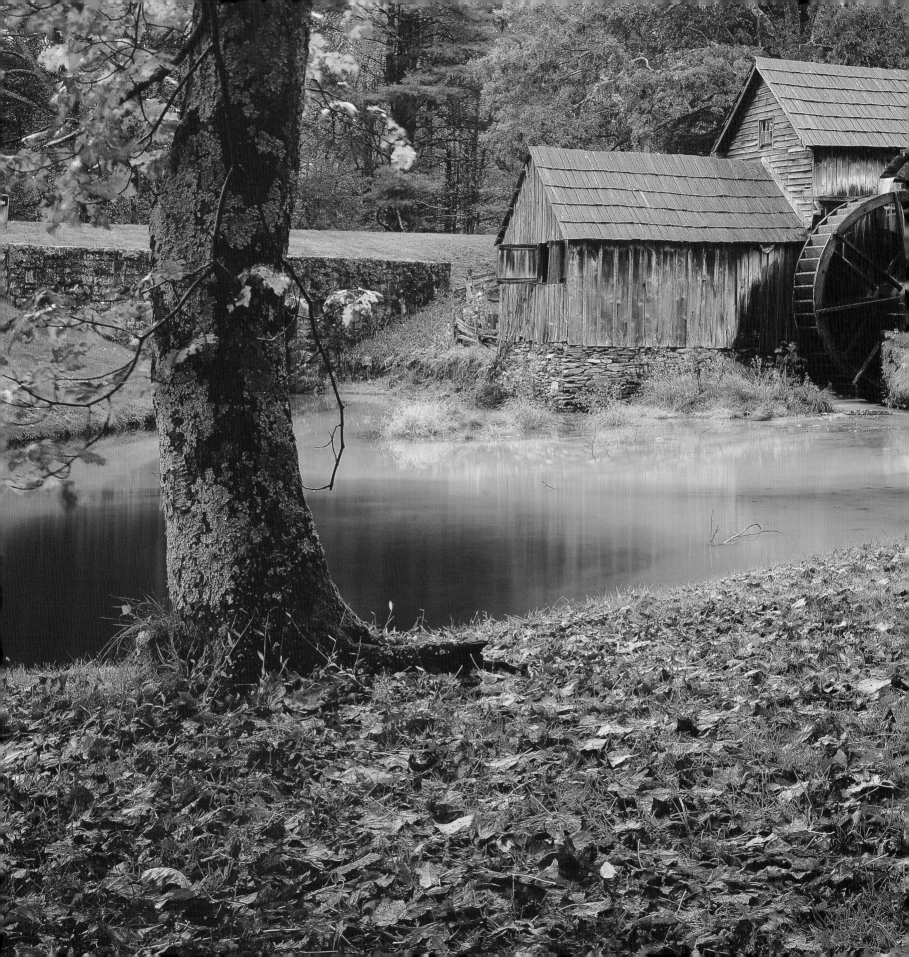

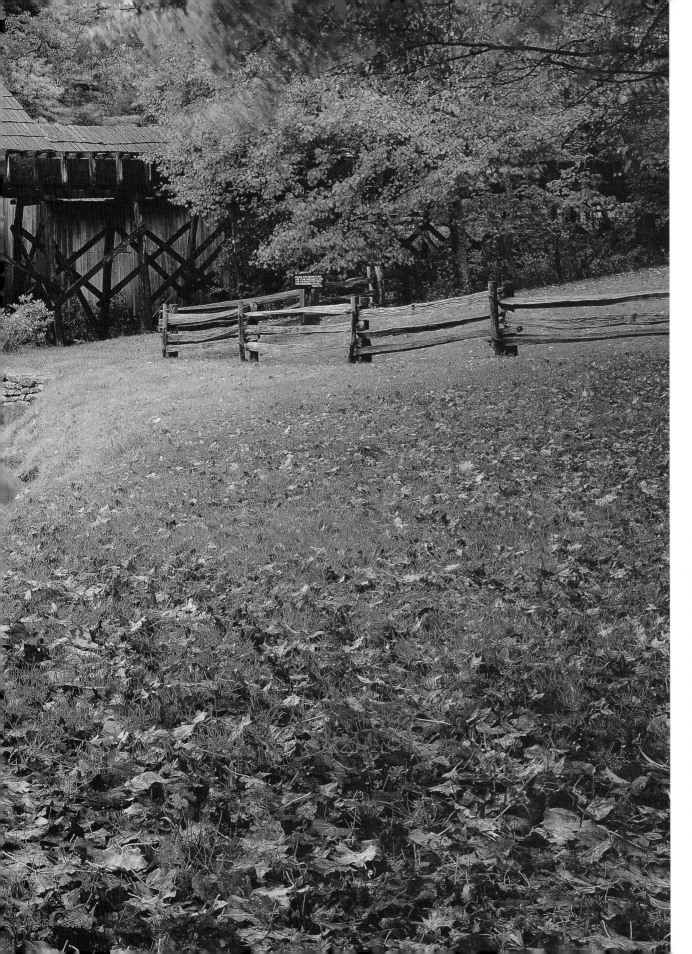

The most photographed sight along the Blue Ridge Parkway, Mabry Mill dates from the early nineteenth century, when small homesteads and remote villages dotted the mountains. A blacksmith's forge, a whiskey still, and a wheelwright's shop are nearby.

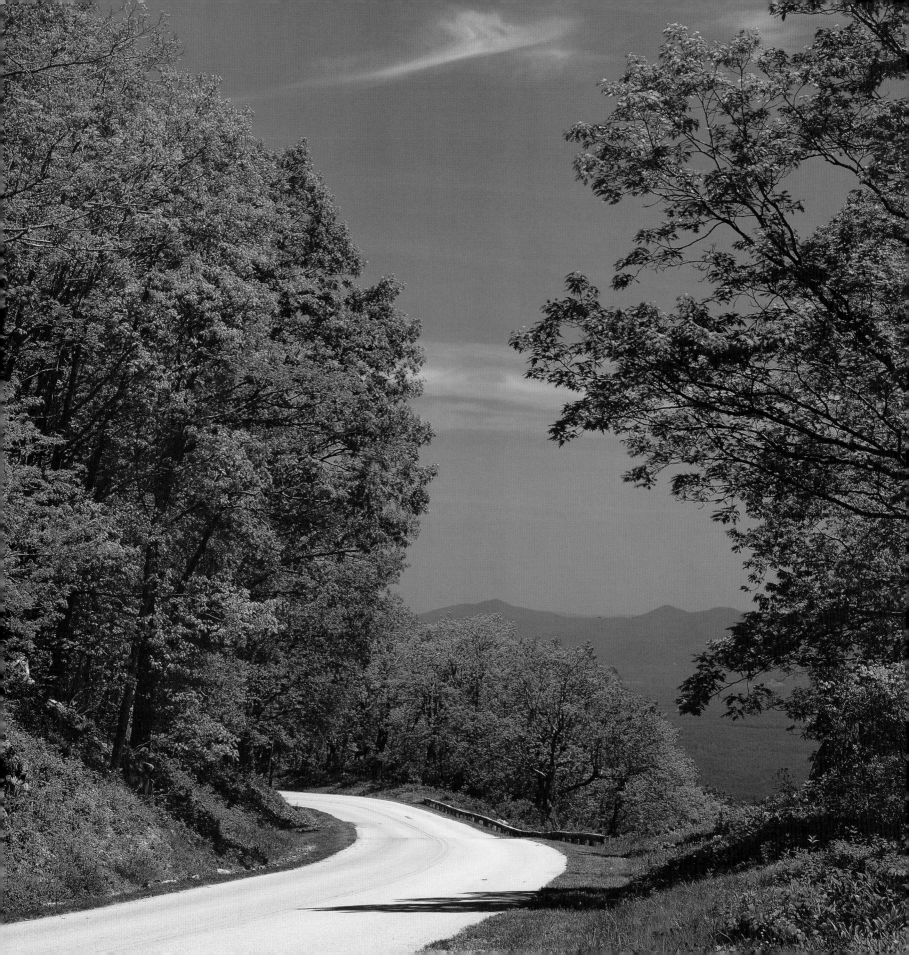

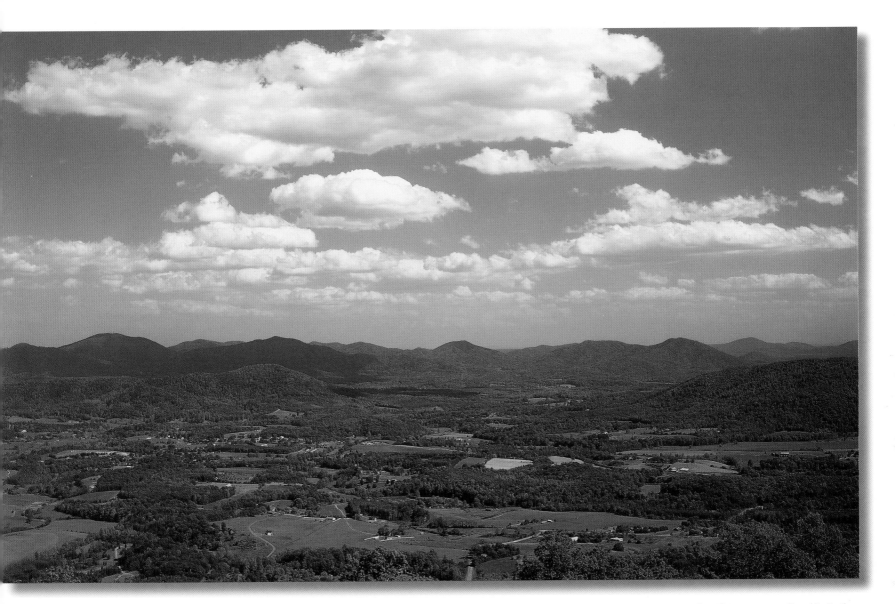

Clouds form along the slopes of the distant Appalachian peaks, high above the James River Valley. The river, with its combination of challenging rapids and calm backwaters, is a favorite destination for paddlers.

Virginia's 217-mile stretch of the Blue Ridge Parkway attracts hikers on their way to more than 20 Appalachian Trail access points, as well as families and RV motorists. Four campgrounds and a guest lodge line the route.

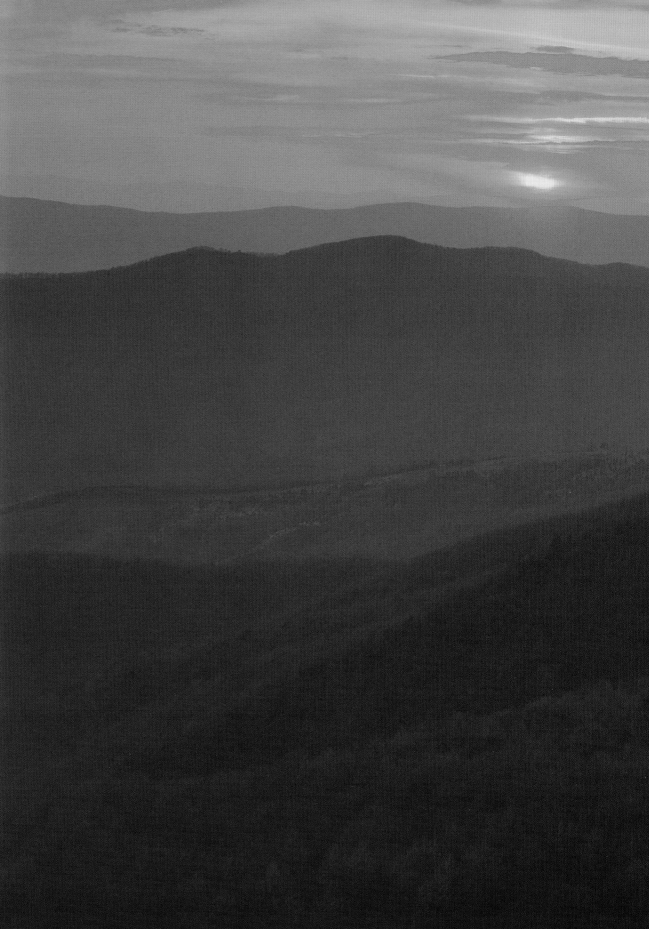

More than a third
of Shenandoah
National Park is
protected under
the federal govern-
ment's Wilder-ness
act, as "an area
where the earth
and its community
of life are untram-
melled by man."
Even the parts of
the park once
settled or logged are
slowly returning to
their natural state.

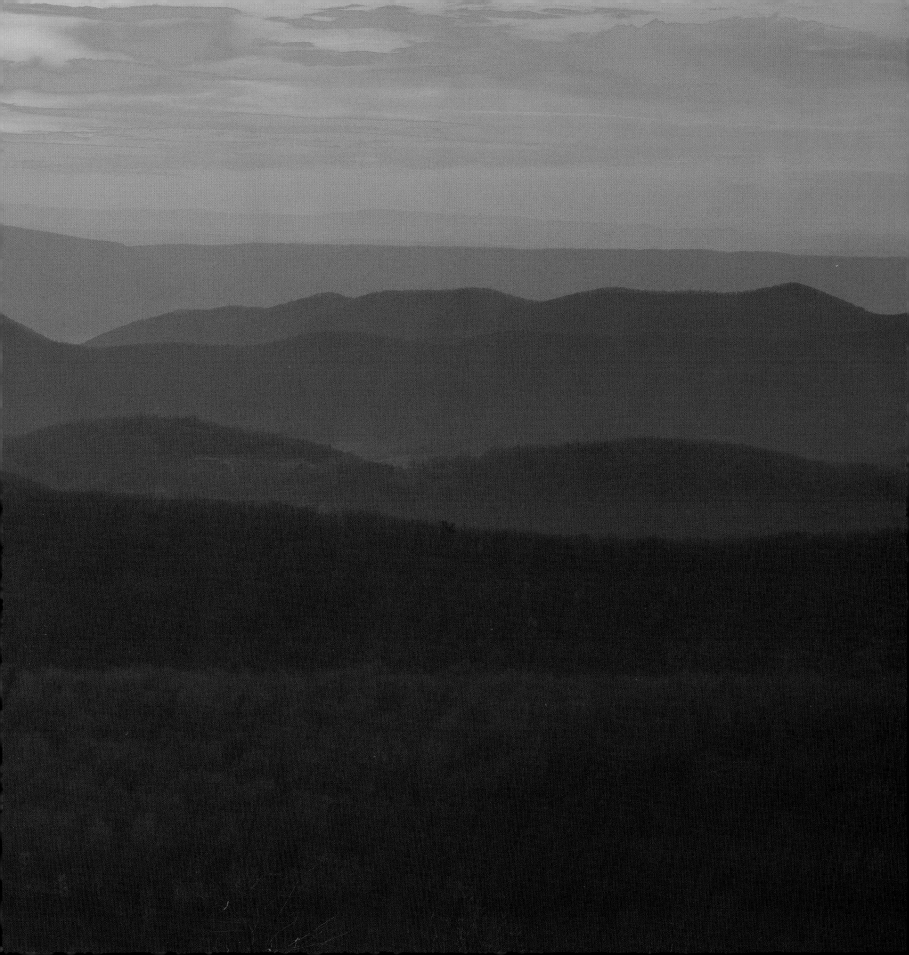

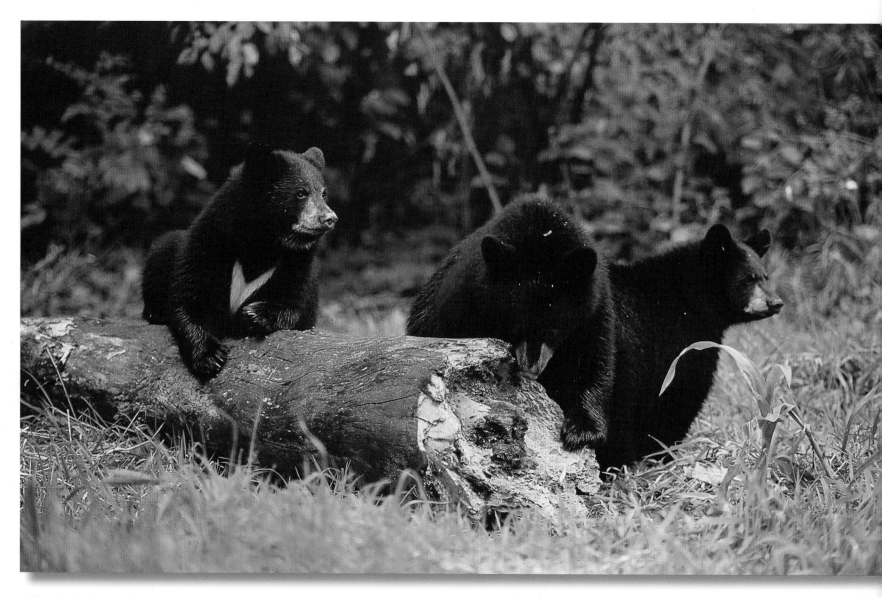

Black bear cubs are born in the Appalachian Mountains in February, but spend their first few months nursing within the den. In April or May, they emerge and spend the summer following their mother closely, learning to forage for food.

Historians agree that the name Shenandoah is probably native in origin, but there are a number of alternate translations, such as "Daughter of the Stars," "Silver River," or "River of High Mountains."

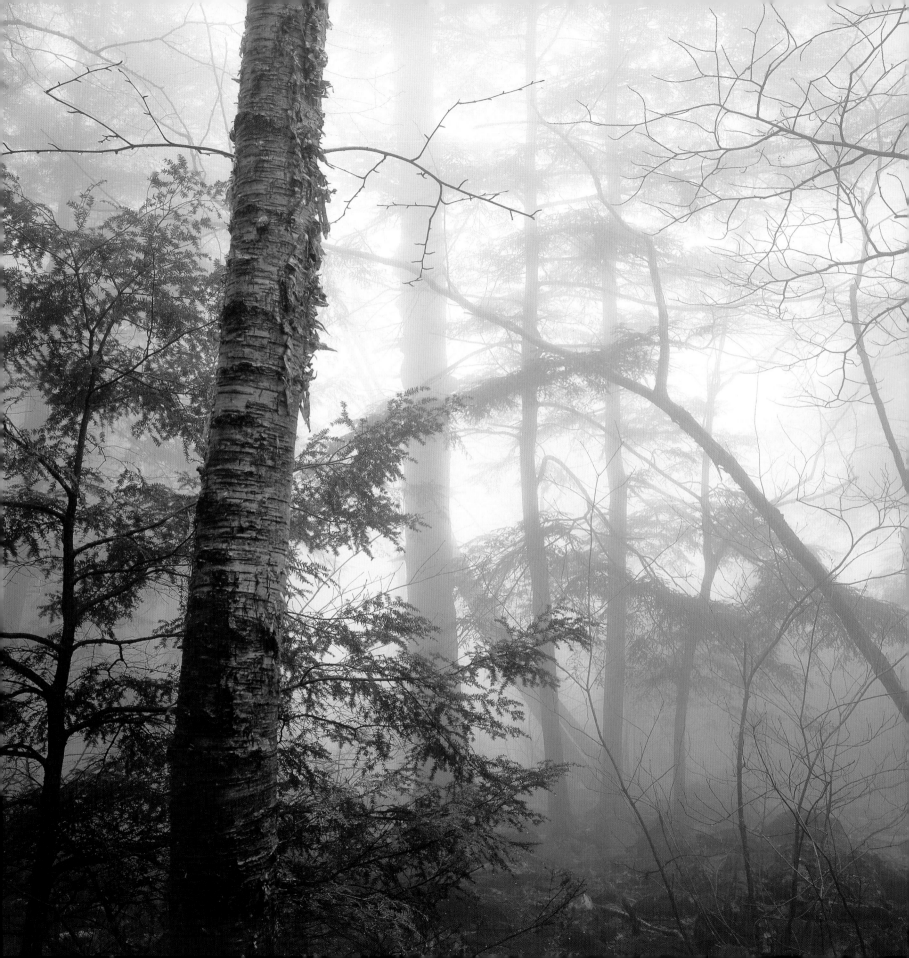

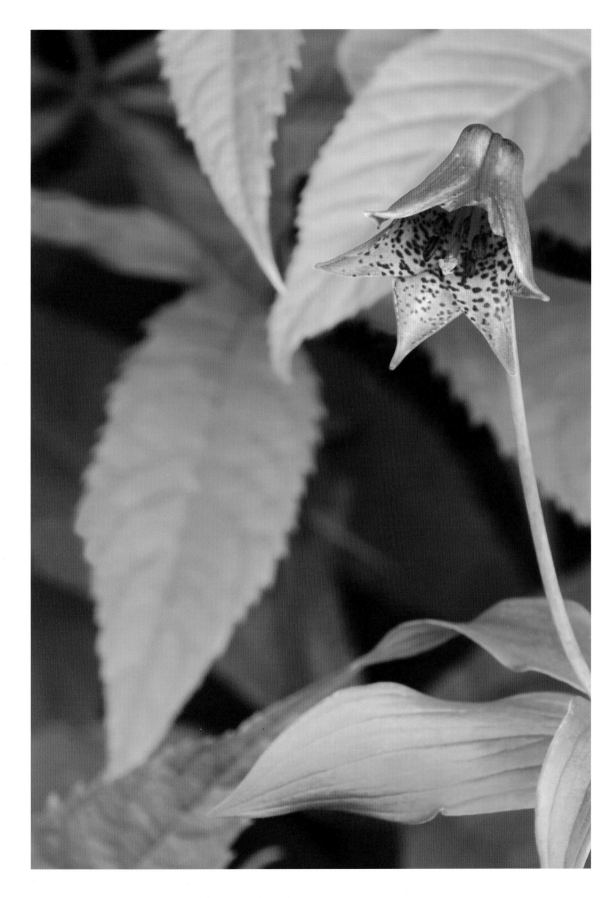

George Washington National Forest and Jefferson National Forest together encompass 1.8 million acres in Virginia, West Virginia, and Kentucky. Part of the Appalachian Range, about 80 percent of the preserve is hardwood forest.

FACING PAGE –
The 2,144-mile Appalachian National Scenic Trail passes through Virginia on its route from Maine to Georgia. Opened to hikers in 1937, the trail is primarily maintained by volunteers, who donate 175,000 hours of time each year.

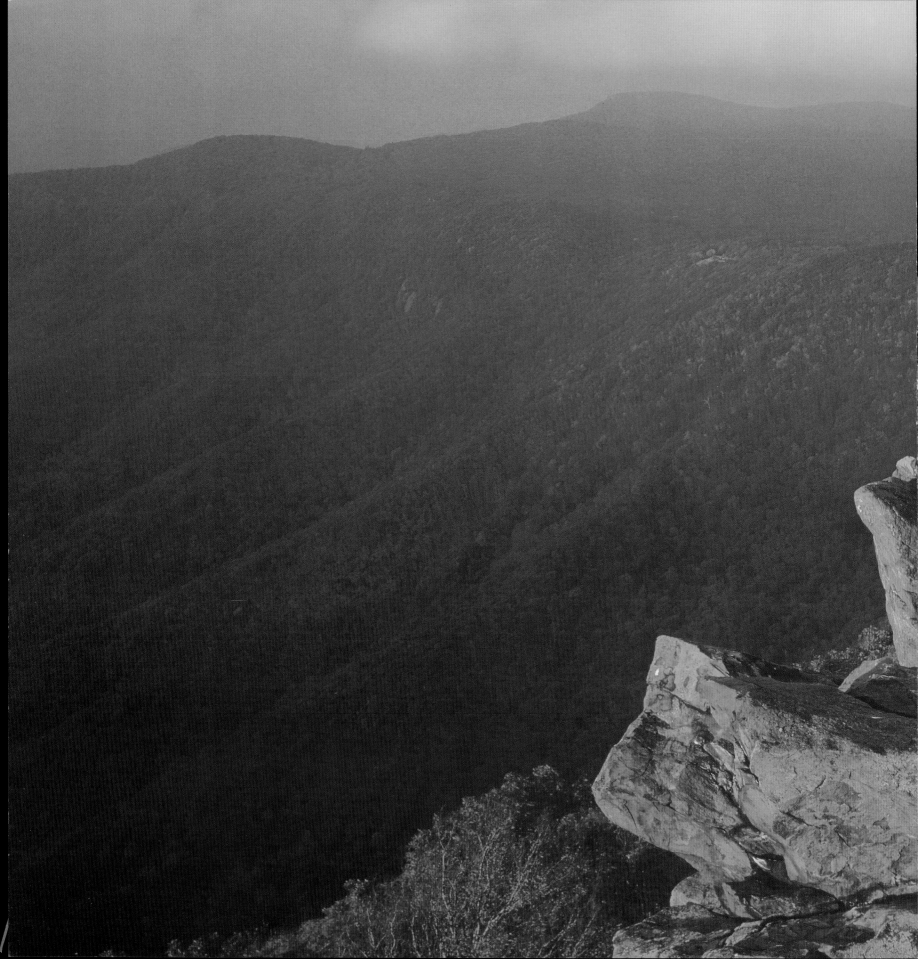

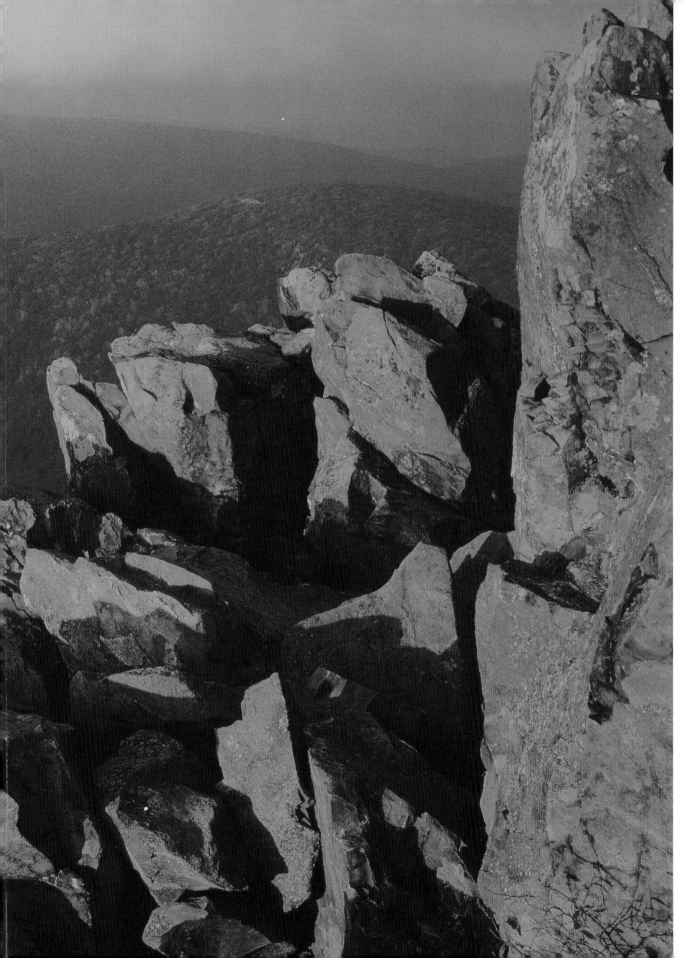

From Skyline Drive, it is less than two miles to the summit of Hawksbill Mountain, the highest peak in Shenandoah National Park at 4,051 feet.

Photo Credits

Terry Donnelly 1, 3, 81, 86, 87

Paul Rezendes 6–7, 13, 34, 35, 39, 40

Richard T. Nowitz/Folio, Inc. 8, 24, 25, 33, 62–63, 67, 74–75

Tom Till 9, 45, 46–47, 61, 69, 84–85, 94–95

Jeff Greenberg/Unicorn Stock Photos 10

Roger Foley/Folio, Inc. 11

Dennis Johnson/Folio, Inc. 12

Walter Bibikow/Mach 2 Stock Exchange 14–15, 20, 27, 60, 73

Andre Jenny/Unicorn Stock Photos 16

Michael Hubrich/Dembinsky Photo Assoc 17

Ted Hooper/Folio, Inc. 18

Everett Johnson/Photri, Inc 19

W. Bertsch/Mach 2 Stock Exchange 21

C.W. Biedel, M.D./Photri Inc 22–23

Walter Bibikow/Folio, Inc. 26

R. Krubner/Mach 2 Stock Exchange 28–29

Jeff Greenberg/Folio, Inc. 30–31, 68

Catherine Karnow/Folio, Inc. 32

Michael Ventura 36–37, 38, 58

Starke Jett/Folio, Inc. 41

Adam Jones 42–43, 70–71, 76–77, 78, 82–83

James Kirby/Photri Inc 44

Jürgen Vogt 48–49

Mark E. Gibson/Dembinsky Photo Assoc 50, 51, 5

Jeff Greenberg/Photri Inc 53, 72

John Skowronski/Folio, Inc. 54, 55, 59

Cameron Davidson/Folio, Inc. 56–57

Fred J. Maroon/Folio, Inc. 64–65

G. Alan Nelson/Dembinsky Photo Assoc 66

Mark J. Thomas/Dembinsky Photo Assoc 79

Terry Donnelly/Dembinsky Photo Assoc 80

Scott T. Smith 88–89, 92

Bill Lea/Dembinsky Photo Assoc 90

Walter P. Calahan/Folio, Inc. 91

Mary Terriberry/Shutterstock.com 93